IMAGES
of America
THE CINCINNATI SOUND

On the cover: In this c. 1959 photograph, rockers Dale Wright and the Wright Guys perform in a Cincinnati area school auditorium. (Dale Wright.)

IMAGES of America
THE CINCINNATI SOUND

Randy McNutt
Foreword by Jim LaBarbara

Copyright © 2007 by Randy McNutt
ISBN 978-0-7385-5076-3

Published by Arcadia Publishing
Charleston SC, Chicago IL, Portsmouth NH, San Francisco CA

Printed in the United States of America

Library of Congress Catalog Card Number: 2007925804

For all general information contact Arcadia Publishing at:
Telephone 843-853-2070
Fax 843-853-0044
E-mail sales@arcadiapublishing.com
For customer service and orders:
Toll-Free 1-888-313-2665

Visit us on the Internet at www.arcadiapublishing.com

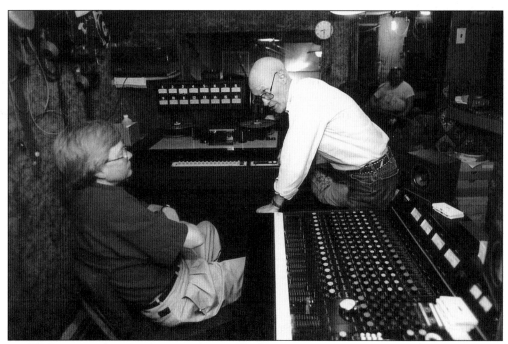

At Tip-Toe Recording Studio in Colerain Township, singer Bill Watkins (right) confers with producer Randy McNutt during the recording of the album *That Rocking Country Man* for Gee-Dee Music of Germany. This book is dedicated to Bill. He is a true friend, a rockabilly original, and one of the nicest guys in the record business. (Dick Swaim.)

CONTENTS

Acknowledgments — 6

Foreword — 7

Introduction — 8

1. Turn Your Radio On — 11
2. The Midwestern Hayride — 21
3. Twist and Shout — 33
4. Hit Men — 47
5. Among the Stars — 57
6. Country Days — 73
7. Soul Serenade — 87
8. At the Hop — 97
9. They Rocked — 107

Bibliography — 127

ACKNOWLEDGMENTS

The music industry is much different than when I naively jumped into it in the halcyon days of the 45-rpm vinyl disc. In those times, disc jockeys, singers, and musicians appeared at local nightclubs, car dealerships, amusement parks, roller rinks, and department stores. Anyone could approach them to discuss the latest records.

When the mystique of the recording studio lured me behind the console, I met singer Wayne Perry, and we became the youngest professional production team in Cincinnati. We used Wayne's soul band, the Young Breed, on our first recording session, along with James Brown's horn players. Avco-Embassy Records of New York came calling. We were off and revolving!

Somewhere along the way, however, I left the wacky record business for books and journalism. But I never forgot the people I met in music. In fact, I continued to make new friends.

Appropriately, this book is a logical extension of my experiences. But I could not have written it without help. I thank Jim "the Music Professor" LaBarbara for taking an interest in the project and writing the foreword. Jim is a knowledgeable air personality who has lived the American music scene. He brings credibility to everything.

I also thank the late Harry Carlson, founder of Fraternity Records, who sat for hours in his suite at the Sheraton Gibson Hotel while I asked questions. Harry was a witty, kind, honest man—a record business rarity. He is missed.

Other important contributors include Rusty York, musician extraordinary and owner of Jewel Recording in Mount Healthy; Shad O'Shea, former studio and label owner, independent producer, and author; Bill Watkins, my partner in song; singer Dale Wright, who has helped me so many times; producer Carl Edmondson, a talented guitarist and good friend; and Bob Armstrong of the Casinos, a gifted keyboard player who has contributed immensely to our local and national music culture.

Others who helped include Don Mangus, Terry Pastor, Jim Brown, Stephen Kelley, Shelly Nelson, Otis Williams, Len Gartner, Kent Goforth, Charles Spurling, Steve Lake, Rick Kennedy, Bob Snyder, Michael Banks, Dick Swaim, Rob Hegel, Jury Krytiuk, Steven Rosen, Beth and Steve O'Neil, Bob Risch, Mick Patrick, Kim Cooper, Allen Howard, Julie Edmondson, Larry Goshorn, and Michael O'Bryant.

Finally, I thank my wife and line editor, Cheryl Bauer, for her invaluable advice, and my book editor, Melissa Basilone, for her patience and good judgment. Their guidance was essential.

FOREWORD

I had no idea how vital and significant the Cincinnati music scene was when I arrived from Cleveland in 1969 to take a job at WLW Radio. Our television station, WLW-T, had three daily shows, each with a full band. This was unheard of, even then. Plus *Midwestern Hayride* was seen all over the country.

Vivienne Della Chiesa asked me to cohost her afternoon television show, even though it would soon go off the air. Frank Brown, her bandleader, was one of the best trumpeters I had ever heard. One day a local high school girl sang. We raved about her. That girl, Randy Crawford, would go on to sell millions of records all over the jazz world.

Around town, much was happening. Pete Georgeton, owner of the Inner Circle nightclub, called me and said, "Mr. Brown would like you to join him at his table tonight." What a thrill. James Brown and I, surrounded by his entourage, talked long after the club closed that night. Once, after a concert, an old engineer from King Records joined us. James started talking about how he had been everywhere but he could not duplicate the sound they got at King's studio in Cincinnati. Whenever I mentioned my friend Otis Williams, James acknowledged that Otis paved the way for black vocalists by crossing into pop music. Otis not only sang hits, he was also a great producer. He produced "The Twist" for Hank Ballard—right here in town. Chubby Checker covered it note for note, and it is one of the biggest-selling records of all time.

At a New Year's Eve party, Lonnie Mack, lost in his guitar, played right through midnight. The promoter yelled at me to get onstage and count down. I waited. You do not interrupt a legend.

In the early 1970s, I sat in a restaurant with Paul Dixon, Kenny Price, and Bob Braun after a union meeting. We were going to strike because the *Hayride* dancers wanted a raise. Kenny shook his head and said, "They'll get the raise, but the show is done." Shortly after that, despite the *Hayride*'s success in 60 markets, Avco dropped Kenny and the show.

The demise of the *Hayride* meant more than the end of a show. It signaled the beginning of the end of Cincinnati as a national music power. Fortunately, that was not the end of the Cincinnati music story.

—Jim LaBarbara

INTRODUCTION

Imagine visiting Cincinnati area nightclubs—from the rocking Inner Circle to the twanging Dude Ranch—and seeing star performers who had stopped by to listen to local music. On any given night from the early 1940s through the late 1960s, in fact, a club hopper could scan the audience and possibly see James Brown, Conway Twitty, Bill Doggett, Hank Ballard, and other nationally known performers sitting comfortably at tables like anyone else. And if the crowd's luck held, these important entertainers might accept invitations to sit in with the band.

The presence of so much talent in one place might surprise people today. But in those days Cincinnati was an active and highly respected component in the American music machine. The city turned out hundreds of nationally and regionally charted records, hosted network and local music television shows (including the *Midwestern Hayride*), entertained music lovers at sock hops and swank nightclubs, and provided jobs for performers, producers, sidemen, songwriters, and music executives.

The city that introduced hometown pop singers Doris Day, Mel Carter, Rosemary Clooney, and Andy Williams also gave us country hit-makers Kenny Price and Cowboy Copas and rhythm and blues men Bootsy Collins, the Isley Brothers, and Babyface. Other artists, including Hank Williams, came into town to record.

While pioneering talk show host Ruth Lyons—a fine pop songwriter—presented her music on radio and television, rough-edged country and blues players performed in local clubs that operated at nearly all hours.

"I used to walk around and see Freddy King and James Brown and other famous black performers," said Bob Armstrong, the keyboard player with the Casinos band. "There they were! One day I was asked to sit in on sessions over at King Records. In those days, the music wasn't black and white. It was just music, and we loved it."

The world loved it, too. As a result, King Records has a legacy that is disproportionate to its original size and stature. The company's jazz, R&B, bluegrass, and country artists and their songs have influenced generations of musicians.

In 1959, R&B singer Hank Ballard wrote "The Twist"—the song that would unleash a worldwide dance sensation—in a Cincinnati hotel room and recorded his original version at King Records's studio. The company's address, 1540 Brewster Avenue in Evanston, is still known worldwide to lovers of American roots music. A few collectible King albums sell for thousands of dollars.

Years before Music Row opened in Nashville, Cincinnati's musicians were busy building a country music center through records and radio. Primarily they were here because of powerful WLW, the self-proclaimed Nation's Station (its call letters stand for World's Largest Wireless). They picked up extra money from playing on recording sessions at King, founded in 1943 by

record shop owner Sydney Nathan. It was a mutually beneficial arrangement. WLW broadcast live country-music shows featuring big-name acts and maintained a talented staff of pickers that included guitarist Zeke Turner and banjo man Grandpa Jones, who also played in local clubs and on recordings. Radio competitors WKRC and WCKY also broadcast all sorts of musical programs.

Soon King became one of the largest independent record companies in America. It had under contract many major country stars of the day, including Jones, Copas, Hawkshaw Hawkins, Jack Cardwell, Hank Penny, Clyde Moody, Wayne Raney, and the Delmore Brothers. For years King did nearly everything under one roof: master records, design and print covers, and record songs.

But what made Cincinnati's music interesting was its diversity. It was big enough to accommodate television singers Bonnie Lou, who cut country and rockabilly hits over at the King studio in the mid-1950s; Marian Spelman and Ruby Wright, who sang on Lyons's television show; Burt Farber, Charlie Kehrer, and other big band leaders; country and blues singers; and later, rock bands—so many rock bands.

By 1949, hit records had turned Cincinnati into a roots music capital. Nathan campaigned to change the name hillbilly music to country. He disliked the stigma. Nathan recorded songs for Appalachians and blacks who were then under-appreciated by the major record companies in New York. King's huge roster of early blues, jazz, and R&B stars included Wynonie Harris, Lucky Millinder, Bull Moose Jackson, Tiny Bradshaw, the 5 Royales, and the Platters before they were stars. Some of Nathan's performers, including organist Bill "Honky Tonk" Doggett, made early rock and roll records.

Meanwhile, Harry Carlson—a pop songwriter and portrait photography studio owner—founded Fraternity Records in 1954. Over the next 20 years, he released hits by Jimmy Dorsey, Cathy Carr, Lonnie Mack, and the Casinos, as well as regional hits by local favorites. Between Nathan and Carlson, Cincinnati was making records for the world.

In those days, Cincinnati was one of a dozen American cities that operated as self-contained hit factories. They came with their own amenable disc jockeys, producers, studios, distributors, publishers, and loyal record buyers. The music spilled over into neighborhood bars, clubs, high school gymnasiums, and even amusement parks. Fans did not have to be trained musicians to recognize the highly individualized sounds of New Orleans, Memphis, Cincinnati, and other local music centers that created hits far from the record industry centers of New York, Nashville, and Los Angeles. Most of the towns had a distinct sound of their own.

As local studio owner E. T. "Bucky" Herzog explained, "Long before Nashville had its Music Row, Cincinnati was making country hits. I recorded Hank Williams in my studio on Race Street. If you wanted a terrific country sound, you came to Cincinnati to hire the many gifted musicians who played for WLW and other radio stations. They stayed on the staff until radio no longer needed them."

On any night, music was thumping from the Surf Club, the Cotton Club (Cincinnati's first integrated nightclub), Castle Farm, the Touche Club, and later northern Kentucky popular rock and roll club the Guys 'n' Dolls. Dance rooms prospered at Coney Island's Moonlite Gardens and LeSourdsville Lake Amusement Park's Stardust Gardens in Butler County.

Country bands performed all over the region. In a 20-mile triangle from Ross to Hamilton to Middletown in Butler County, clubs like the Dude Ranch, the Wayside Inn, the Golden Key, the Blacksmith Shop, and the Club Miami attracted the top country performers in the early 1960s.

To meet the increasing demand for dance music, white soul bands arrived by 1962. Somehow blending seamlessly with country music, the burgeoning rock-soul sound became a regional affair and created new local stars. Cincinnati area bands played in funky—and jumping—roadhouses named the Halfway, formerly an old house located halfway between Hamilton and Middletown on State Route 4, and the Twilight Inn in McGonigle, on U.S. 27, between Hamilton and Oxford. (The floor sagged from the weight of the dancers.) Nobody thought it odd if a singer belted out a country song right after a rollicking soul tune.

Strictly speaking, the Cincinnati sound meant white soul bands. They peaked from 1962 to 1966, blending a little country crying, some blues licks, and the emerging rock sound into a funky roadhouse brew. Its most recognized practitioner is the guitarist Mack, who recorded his hit instrumentals "Memphis" and "Wham!" at the King studio and developed a national following through his Fraternity recordings. Mack represented true diversification of the music. He grew up on country music in nearby Aurora, Indiana, enjoyed listening to the blues, used a black girl group on his records, and listened attentively to blues guitarist Freddy King, who then recorded in Cincinnati. Of course, James Brown and the Famous Flames, King's biggest act, heavily influenced many local musicians.

As the 1960s continued, the Cincinnati sound flourished in clubs throughout southwestern Ohio in the form of soulful horn bands such as Beau Dollar and the Coins and Wayne Cochran and the C. C. Riders. Other bands, including the Young Breed and the Dapps, built loyal followings. The historic Gateway to the South became the place where country met the blues and turned it into rock and roll.

By 1964, however, soul bands found some competition from British-style rockers. Bands flourished in every garage. Over at WSAI, the No. 1 local rock station, disc jockeys pooled their money and brought the Beatles to Crosley Field. The crowd was screaming so loudly that no one actually heard the music. Dick Clark, America's disc jockey to the generations, emceed his own rock shows at LeSourdsville Lake, using local and national acts.

Alienated by the long hair and strange sounds, older soul rockers started leaving Cincinnati. They ended up in Nashville. Tastes were changing. Oddly named "long-haired" bands, such as the Lemon Pipers and the New Lime, started attracting crowds. "The Cincinnati music industry was still exciting," recalled Shad O'Shea, a former WCPO Radio disc jockey who released records for the New Lime, the US Too Group, and other young bands for his Counterpart Records. "The phone rang off the hook with disc jockeys, distributors, and larger labels. I leased so many master tapes to larger labels that I've lost count. My own label reached out as far as Columbus, Lexington, and Indianapolis. It was a regional thing."

By then, however, the music business had already started to become big business. The smaller operators, including Counterpart, were being squeezed out of airplay contention, and radio was becoming increasingly formatted. This damaged the independents. Radio stations all but stopped playing records by local artists. Corporate radio and its central programming removed the local element from the music business. After Fraternity declined and Sydney Nathan died and King moved out of town, there was no place for local talent to go but to Nashville. The exodus continued.

"Cincinnati supplied Nashville with a lot of talent," musician Rusty York observed.

But Cincinnati still had one more chart bullet left. It came in early 1967 as an unlikely tune that echoed across the nation: the Casinos' top 10 ballad "Then You Can Tell Me Goodbye." The record temporarily revived the fading Fraternity label. The Casinos had recorded the song in the King studio, and on its strength they toured the country. "We played with the Beach Boys and a lot of other big bands of the period," recalled Bob Armstrong, the Casinos' keyboard player and background vocalist. "Unfortunately, we couldn't duplicate the hit. By 1973, Cincinnati had dried up as a national music center. I call it the year the music died."

But the previous glory years had given new meaning to the words "Made in Cincinnati." Although the Cincinnati recording kingdom is lost, its music will live forever in the grooves of old records and in the hearts of people who hear those sounds for the first time.

One
Turn Your Radio On

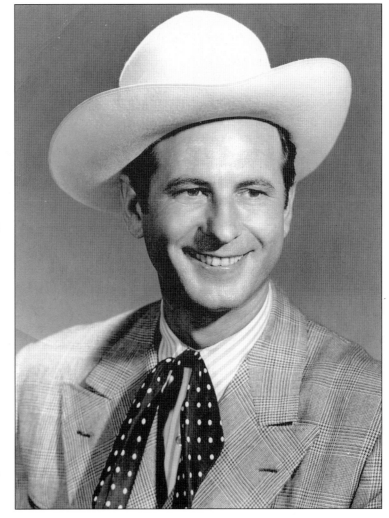

Lloyd "Cowboy" Copas arrived in Cincinnati in 1929 and by the 1940s was a vocalist on WLW's *Boone County Jamboree*. Later he sang in Pee Wee King's Golden West Cowboys and joined the *Grand Ole Opry*. In 1945, he signed a recording contract with King Records. His hits included "Filipino Baby" and "Signed, Sealed and Delivered." Copas also hosted a WKRC radio program, with accompanying book *Cowboy's Favorite Songs*, "as sung by our friend on the air." (Author's collection.)

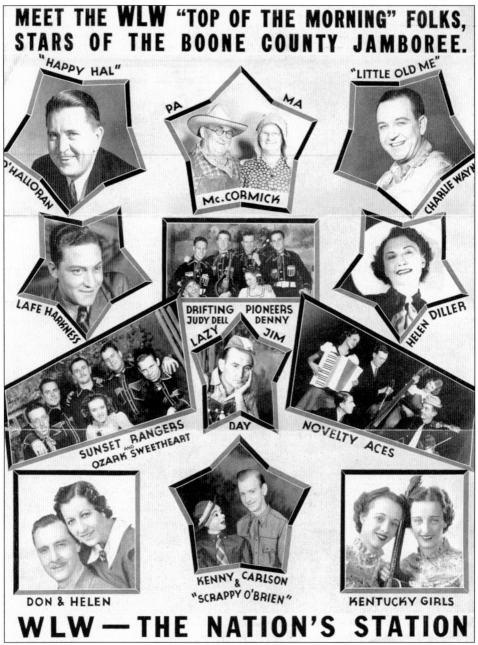

Entertainers pose on this WLW circular sent to homes in the early 1940s. Their *Boone County Jamboree* presented talented country and western acts. The comic presence of Ma and Pa McCormick and Lazy Jim Day appealed to the rural members of the vast audience. Entrepreneur Powel Crosley Jr. founded WLW in 1922. Called the Nation's Station, its powerful signal reached across many states and its varied programs, including *Moon River*, entertained millions of people. Many stars and famous people performed on the station, including Red Skelton, Eddie Albert, Rosemary and Betty Clooney, Homer and Jethro, Chet Atkins, the Mills Brothers, and Fats Waller. In 1942, Andy Williams, then only 11 years old, sang on the 15-minute *Time to Shine* show before heading to school. (Author's collection.)

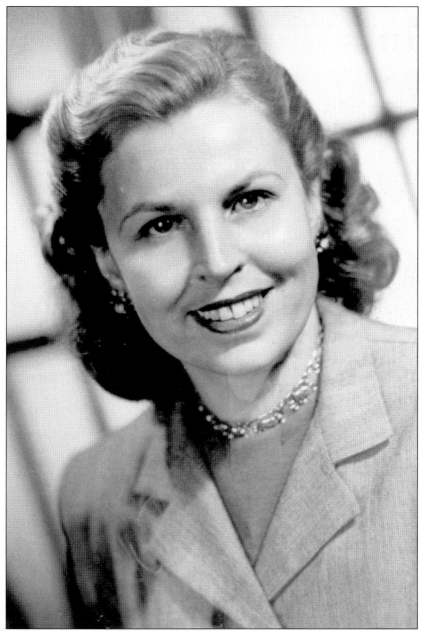

Ruby Wright, a native of Anderson, Indiana, started singing professionally in her home state in 1930. Later she married bandleader Barney Rapp and toured the nation with his group, the New Englanders. Eventually they settled in Cincinnati and performed at the Lookout House in northern Kentucky and at area hotels and nightclubs. In 1952, Wright joined the staff of WLW and WLW-T. She hosted a radio show, *Dixieland Unlimited*, and later recorded a regional hit with Ruth Lyons's "Let's Light the Christmas Tree" for Fraternity Records. For 20 years she appeared on television shows hosted by Lyons and Bob Braun, and became one of Cincinnati's most recognizable television personalities. Before Rapp left the music business to become a local travel agent, he replaced his wife in the band with a younger Cincinnati singer, Doris von Kappelhoff, who changed her name to Doris Day. (Author's collection.)

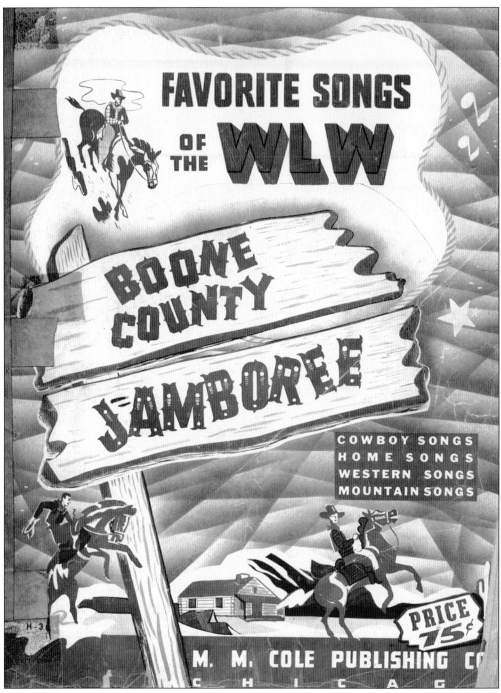

Boone County Jamboree became one of WLW's more popular programs in the 1940s. Although now remembered for its hot country acts, the show also included some popular singers such as the Williams Brothers. The show's material featured cowboy songs, home songs, western songs, and mountain songs in an era when they were considered individual genres. They now fall under the umbrella of country music. The *Jamboree* continued until it gave way to a more "modern" program, the *Midwestern Hayride*. (Author's collection.)

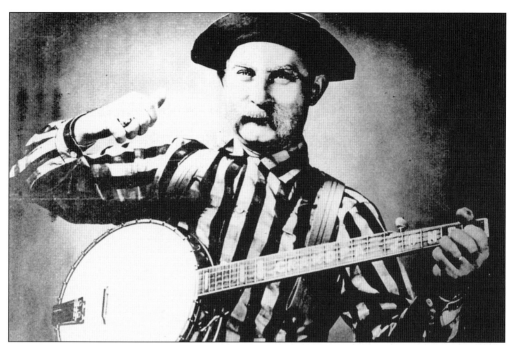

Louis "Grandpa" Jones, a Kentucky native who grew up in Akron, strums his familiar banjo in this early-1950s publicity photograph. Jones came to Cincinnati to perform on WLW's music programs. He also played and sang with traveling WLW shows throughout the region. Even as a young man, Jones enjoyed dressing in character as an old man and taking on that persona in his act. (Author's collection.)

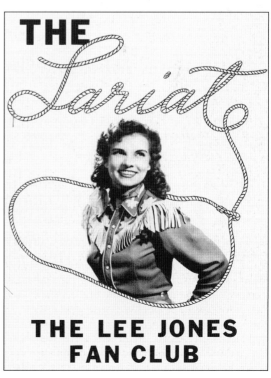

Lee Jones smiles from the cover of her own fan magazine in 1955. The Cincinnati singer had recently resigned from WLW-T's popular *Midwestern Hayride* to accept a position on the *Indiana Hoedown* television show in Indianapolis. In November 1954, she was voted the most popular hillbilly singer in Cincinnati by members of the National Country Fan Club Association who gathered at the Hotel Gibson for their convention. (Author's collection.)

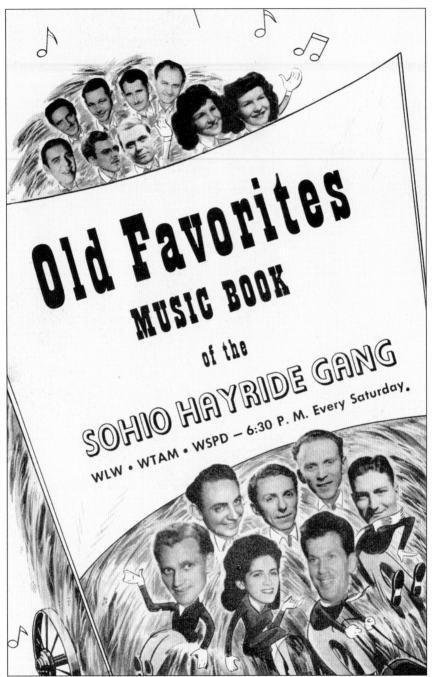

Through sponsoring Standard Oil Company, *Midwestern Hayride* performers offered their original songs to listeners in this late-1940s music book. Songs included "Barn Dance of Long Ago" by Robert E. Hart and Bill McCluskey, "Straddle My Saddle" by Rome Johnson, and "Lonesome Little Darling" by Red and Leige Turner, the original Turner Brothers group. The show also included acts such as the Girls of the Golden West, the Lucky Penny Trio, and Lafe Harkness. McCluskey, the show's producer, was married to Millie Good of the Girls of the Golden West, the show's pioneering western group. (Author's collection.)

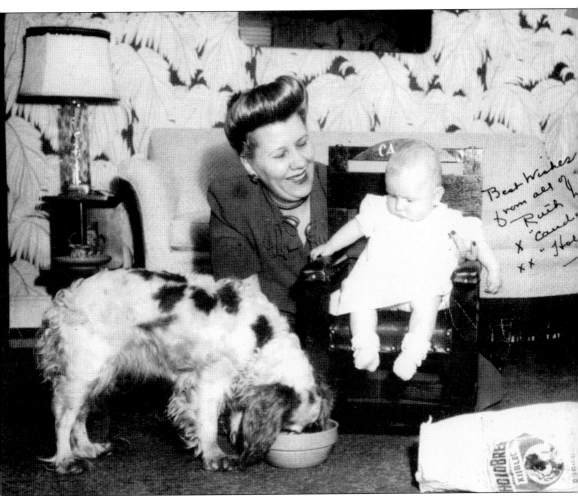

Ruth Lyons plays with her infant daughter in this late-1940s promotional photograph. The Cincinnati native was an accomplished songwriter who composed melodies in her head, not on the piano. At unlikely times and places—on vacation in the Caribbean, for instance—she created melodies to go with her many Christmas songs. In addition to hosting Cincinnati's most popular radio and television shows, she took time to record and write for the major Columbia Records and her own small Candee label in Cincinnati. Johnny Mathis sang her moody song "Wasn't the Summer Short?" and Ruby Wright, who sang on Lyons's *50-50 Club*, recorded Lyons's original "Let's Light the Christmas Tree." Lyons wrote many Christmas songs with strong melodies and lyrics. She retired from the show in 1967. (Author's collection.)

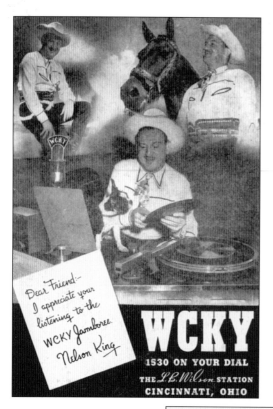

Nelson King of WCKY in Cincinnati looks like a dude cowboy in this promotional postcard. It shows him preparing to play a 78-rpm record. The Portsmouth, Ohio, native called himself the King of the Hillbilly Disc Jockeys. He was nationally known for his influence in breaking country records, and he played them six hours a night, seven days a week. (Author's collection.)

King arrived in Cincinnati in 1938 to work for WCPO Radio. In 1946, he took a job at WCKY to play country music and was instrumental in King Records's rise as an important company. He played its records, appeared at its shows, and even recorded for the label. Nelson King represented the true personality jock in that he could select his music and run his show as he pleased. (Author's collection.)

Bluesy baritone Jimmie Skinner wrote songs for big-name country artists and recorded 10 national country hits himself from 1949 to 1960. He and manager Lou Epstein operated the Jimmie Skinner Music Center at 222 East Fifth Street in Cincinnati, where they sold song folios as well as country and gospel records to customers across the world. Skinner, a Kentucky native, broadcast from the store on WNOP, in Newport, Kentucky. (Author's collection.)

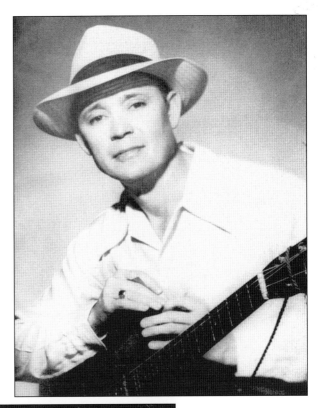

For years Skinner lived in Hamilton, worked there in a potato chip factory, and sang in bars at night. He released songs through many major record companies during his long career, but in April 1950, he sang for Radio Artists of Cincinnati. The company promoted itself as "Your radio friends on records." Skinner recorded this original number in the E. T. Herzog Studio at 811 Race Street. (Author's collection.)

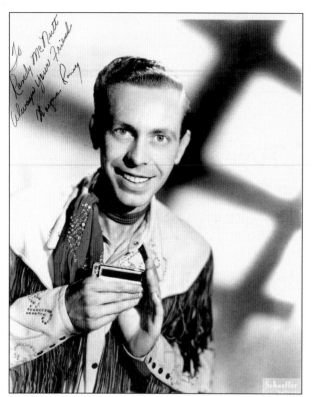

Wayne Raney holds a harmonica, the instrument that helped make him famous. For years his *Jamboree* was broadcast over WCKY, when he was selling hundreds of thousands of mail-order harmonicas. In the late 1940s and early 1950s, Raney recorded for King Records and sometimes played with the Delmore Brothers. Among his bigger hits were "Why Don't You Haul Off and Love Me?" and "Lost John Boogie." (Author's collection.)

Jimmie Logsdon taught himself to play guitar. In Louisville he met Hank Williams, who recommended him to Decca Records. He began a career as a disc jockey and country singer. In 1962, the Panther, Kentucky, native was named host of WCKY's country music *Jamboree*, a job he held until the show was canceled in 1964. He also wrote rockabilly and country songs and recorded for King Records. (Rusty York.)

Two

THE MIDWESTERN HAYRIDE

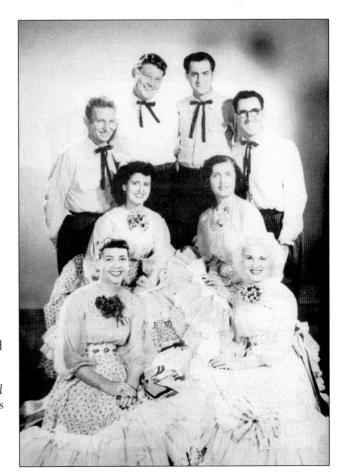

The Midwesterners, a popular Cincinnati square dance group, strike an unfamiliar pose—standing still. The eight dancers were usually leading off WLW-T's long-running *Midwestern Hayride* with a fast-stepping number that set the pace for the show. The group won the National Square Dance Championship in the early 1950s and attracted attention from coast to coast. The show's popularity in Indiana, Kentucky, and Ohio and across the country led to national tours. The group performed in Madison Square Garden in New York City, the Uline in Washington, D.C., and in many other venues. In 1955, the dancers went to Hollywood to appear in the film *The Second Greatest Sex*. The Midwesterners had more than 50 different dancing costumes, all hand sewn by the women in the group. (Author's collection.)

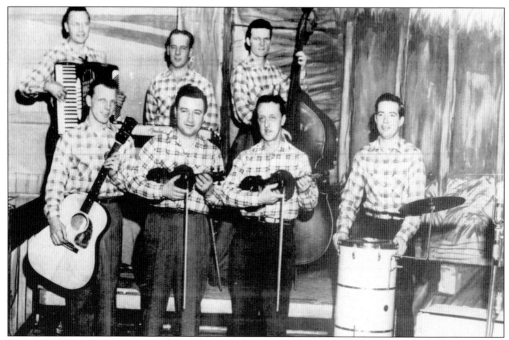

Formed in the mid-1950s, the Hayriders appeared on the *Midwestern Hayride* each week. The band featured members of the original Trailhands group. Players were Russ Helton, bass; Monty Monohan and Gene Masters, fiddle; Bob Shank, rhythm guitar; Jack Brengle, steel guitar; Arthur Bishop, takeoff guitar; and Bill "Bun" Wilson, drums. (Author's collection.)

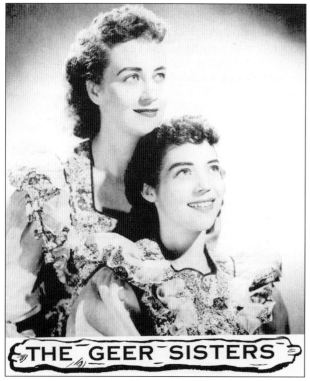

The Geer Sisters started entertaining on the *Hayride* in June 1953. Mary Louise (left), 24, and Jo Ann, 22, moved to Cincinnati from their home in Sidney, Ohio, to sing on the show. They had worked radio and television stations in Dayton and in Alabama. They recorded for RCA's X label and added a youthful touch to the *Hayride* cast. (Author's collection.)

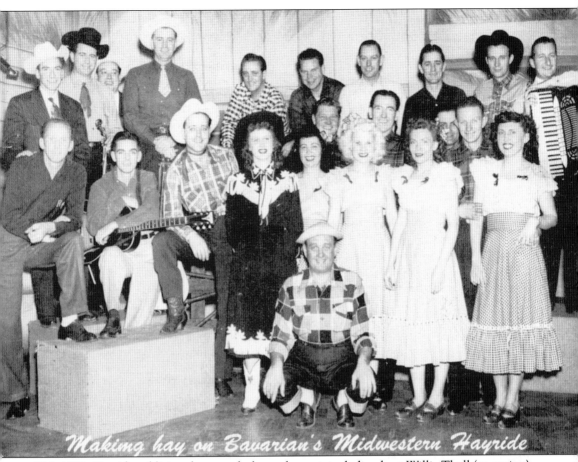

This 1950s *Hayride* publicity photograph shows the cast, including host Willie Thall (squatting) and singer Bonnie Lou to his left, dressed in black with a cowgirl hat. At the time, Bavarian Beer sponsored the show. (Author's collection.)

Willie Thall looks nothing like a bumpkin in his gray suit. But from July 31, 1948, when the *Midwestern Hayride* premiered on WLW-T, through about 1955, Thall appeared on the program as its master of ceremonies, dressing in a floppy hat and plaid shirt. During his other life at WLW-T, he was Ruth Lyons's announcer sidekick on her popular *50-50 Club*. Today he is remembered as a *Hayride* man. (Author's collection.)

The Hayseeds were Sunny Spencer (left) and Lefty Carson, who performed in nightclubs across the nation before coming to the *Hayride* in the 1950s. Spencer was from Bowen, Kentucky. He could play 22 different musical instruments. Carson, a Tennessee native, played bass, guitar, and drums. Both were fine comedians. (Author's collection.)

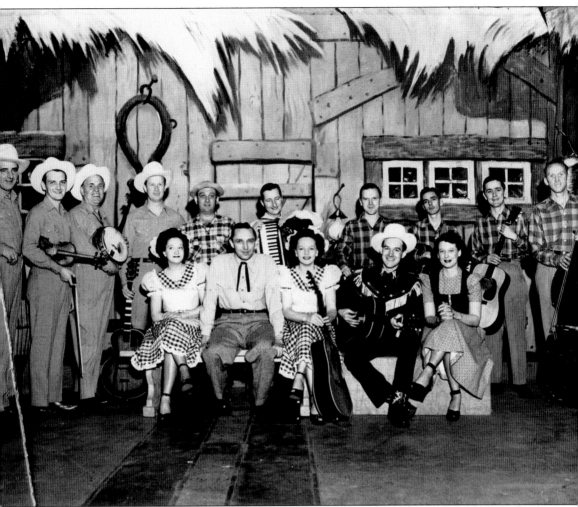

The *Hayride* cast, minus the Kentucky Briarhoppers dance group, pose in this c. 1953 photograph. In the back row, members include emcee Willie Thall standing next to accordionist Buddy Ross, a fixture on WLW-T programs for years. The station used its staff members interchangeably, placing them on various programs at times. Viewers felt as if they knew the personable Thall and other cast members. Although the set seems hastily constructed by today's slick standards, the music was always first class. The *Hayride* quickly became one of Crosley Broadcasting's most consistent programs, running for parts of four decades and doing its time as an NBC network summer replacement series. (Author's collection.)

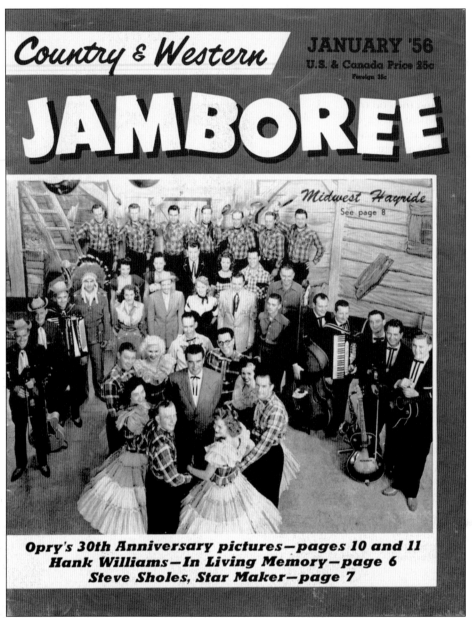

By 1956, the *Midwestern Hayride* had established itself as one of the nation's top-rated rural barn dance shows, being broadcast both on WLW Radio as well as WLW-T. A national magazine, *Country and Western Jamboree*, featured the program in a pictorial spread that January. The story explained that the *Hayride* first became NBC's summer series in 1951, replacing the *Milton Berle Show*. Surprisingly, the program gained solid ratings in Boson, Philadelphia, and other East Coast cities. The next summer, NBC brought the *Hayride* back and ratings climbed even higher. It was on the air every summer from 1951 to 1955, except for 1953. Then, in the fall of 1955, the program returned to the network for a regular 30-minute show. Locally, on radio and television on Saturday night, the show lasted up to 90 minutes, being broadcast live from Crosley Square in downtown Cincinnati. It was not rehearsed. The show also aired on WLW-C television in Columbus and WLW-D in Dayton. (Author's collection.)

Despite her slight stature (five feet, 96 pounds), Dixie Lee could belt out a song. The native of Horse Cave, Kentucky, performed on the *Boone County Jamboree* on radio and then on the *Hayride*, where she stayed for three years. She could also play the upright acoustic bass, which must have overshadowed her. She made Groesbeck her home. (Author's collection.)

The Trailhands western band performed on WLW and WLW-T in the 1950s. Several members sang and harmonized. Players were Russ Helton, leader, bass, and rhythm guitar; Randy Dirks, accordion and piano; Bob Shank, banjo and rhythm guitar; Monty Monahan, mandolin, fiddle, guitar, and trumpet; and Chubby Howard, steel guitar. Later Howard became a disc jockey at WPFB Radio in Middletown and performed in many country bands. (Author's collection.)

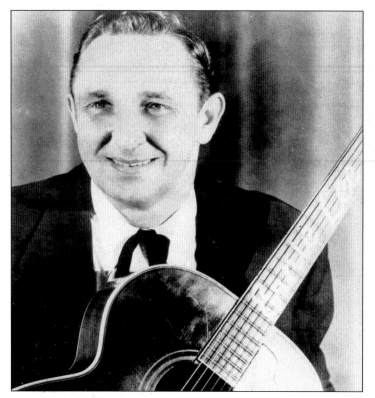

Ernie Lee, a native of Berea, Kentucky, started performing at age 10. His first break in radio came when Red Foley took ill before a network radio show. Lee filled in. He arrived at WLW in 1947, left it in 1953, and rejoined the station in February 1956. He was known for his easy-going style and his pleasant singing voice. (Author's collection.)

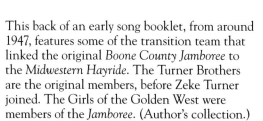

This back of an early song booklet, from around 1947, features some of the transition team that linked the original *Boone County Jamboree* to the *Midwestern Hayride*. The Turner Brothers are the original members, before Zeke Turner joined. The Girls of the Golden West were members of the *Jamboree*. (Author's collection.)

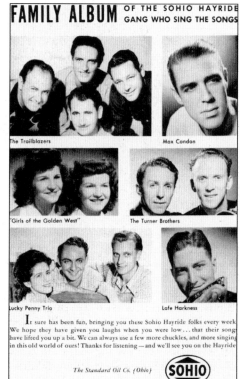

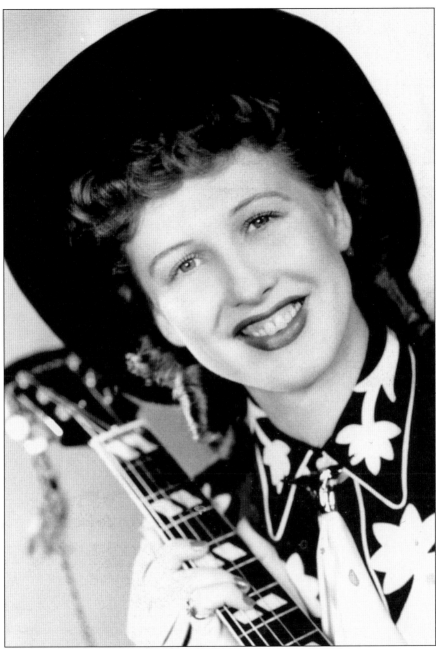

The talented and gracious Bonnie Lou started singing on the *Hayride* in its early days of the 1950s and continued to make appearances on it for years. (Offstage she is Bonnie Lou Okum.) She was blonde and in her 20s when she stepped onto the stage at Crosley Square, and she captivated audiences with her singing and yodeling. She came from Towanda, Illinois, and started in radio in Bloomington, Illinois, and later worked in Kansas City, Missouri. She sang country and pop before coming to WLW in 1945. She was one of the *Hayride's* stars when it went on national television. She went on to star in other WLW-T shows, including the *Paul Dixon Show*, where she honed her comic abilities. Bonnie was one of the true stars of the WLW family. (Author's collection.)

Rudy Hansen flashes a familiar smile, the one seen by millions of *Midwestern Hayride* viewers in the 1950s. Hansen's nickname was "Rockin'" Rudy Hansen, because of his enthusiastic style. The native of Wyck auf Fohr, Germany, traveled with USO tours before joining Crosley Broadcasting in September 1954. He recorded for RCA's X label and was known for his triple yodel. (Author's collection.)

NBC advertised the *Hayride* in broadcasting trade publications, and in the process promoted its local affiliate, WLW and WLW-T. The first time the program was broadcast on the network was in June 1951, when it replaced the *Sid Caesar-Imogene Coca Show*. For years the stars were Bonnie Lou and Charlie Gore. The network show ran for 60 minutes. (Author's collection.)

30

In this c. 1957 publicity photograph, singer Bobby Bobo shows why he was so popular with his fans. His smile added warmth and charm to his singing. The Brookfield, Ohio, native joined Crosley Broadcasting in November 1955. He stood six feet, five inches and weighed 185 pounds. Bobo went on to produce hit country records on the Boone record label for his *Hayride* partner, Kenny Price. (Author's collection.)

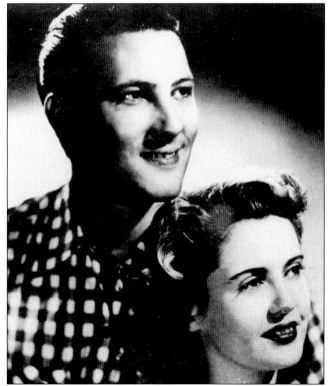

Phyllis and Billy Holmes, known as the Melody Mr. and Mrs., started performing on the *Hayride* in 1953. Phyllis came from Chicago, her hometown, where she performed as the Melody Miss. They became engaged soon after meeting. Billy came from Glasgow, Kentucky. He played guitar, harmonica, bass, piano, and harp. He met his future wife while they were performing at a Chicago radio station. (Author's collection.)

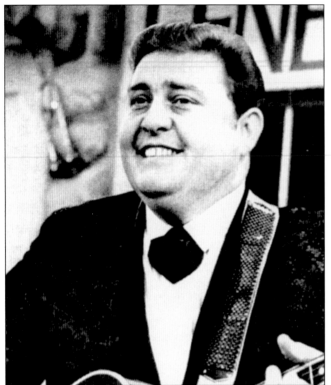

Kenny Price, nicknamed "the Round Mound of Sound," performed on the *Midwestern Hayride* from the 1950s to the 1970s. He was a northern Kentucky resident who appeared in Cincinnati often. He recorded for the Boone record company in Union, Kentucky, and later for RCA. He recorded a number of national hits. He later became nationally famous for appearing on *Hee-Haw*. (Author's collection.)

The Kentucky Boys were guitarist Zeke Turner (left) and baritone vocalist Marshall "Slim" King, who contrasted on the air, physically and musically. Nicknamed Mr. Short and Mr. Tall, they were among the more popular cast members of the *Hayride*. Turner stood five feet, five inches tall and weighed only 120 pounds; King was six foot, three inches and 200 pounds. Turner provided comic relief, while King was quiet. After they finished a song, King would often say, "That was the best I ever heard." Turner joined the WLW staff in 1948 and initially worked with Red Turner (they were not really brothers), but when Red retired due to illness in the mid-1950s, King replaced him. (Author's collection.)

Three

TWIST AND SHOUT

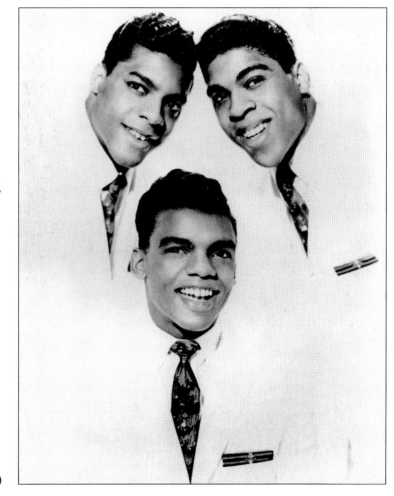

O'Kelly, Ronald, and Rudolph Isley began as a gospel group in Cincinnati before moving to New York in 1957. Five years later they had their first big hit, "Twist and Shout." They also wrote and recorded many other hits, including "This Old Heart of Mine," "It's Your Thing," and "That Lady." Their early success encouraged performers of all races in Cincinnati to persevere. Eventually the brothers added other players, including younger brothers Ernie and Marvin, and cousin Chris Jasper. (Author's collection.)

Denzil "Dumpy" Rice plays piano at a recording session in Cincinnati in this c. 1990 photograph. He combined black rhythms and country themes to become one of the finest boogie-woogie pianists in the region. The Hamilton resident played on hundreds of recordings and in local nightclubs. In the 1960s, he played for guitarist Lonnie Mack and country singer Conway Twitty. (Author's collection.)

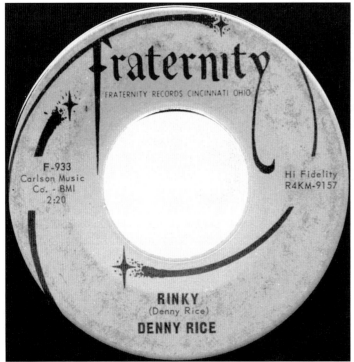

Fraternity Records released Rice's single "Rinky," an instrumental that received airplay in Greater Cincinnati in the early 1960s. For the next 20 years, Rice recorded singles for several record companies. His versatile style—he could play rock, blues, and country—influenced generations of musicians. (Author's collection.)

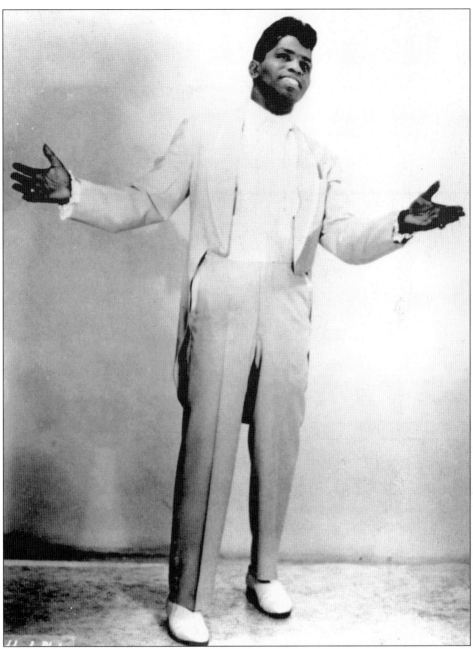

James Brown and the Flames first recorded at King Records in Evanston in 1956. They sang four songs, including "Please, Please, Please," which became a huge hit for the company. Brown, a Georgia native, quickly became King's most popular act. He recorded some of his hits at King Records and later operated a production company office there. His many King hits included "Papa's Got a Brand New Bag," "I Got You (I Feel Good)," "Cold Sweat," and "It's A Man's, Man's World." Cincinnati was a perfect place for Brown to develop because its musical roots were both in the North and South. Although owner Sydney Nathan did not at first appreciate Brown's shouting style, he came to appreciate the revenue that Brown earned for the company. Their rocky relationship became one built on mutual respect and money. (Author's collection.)

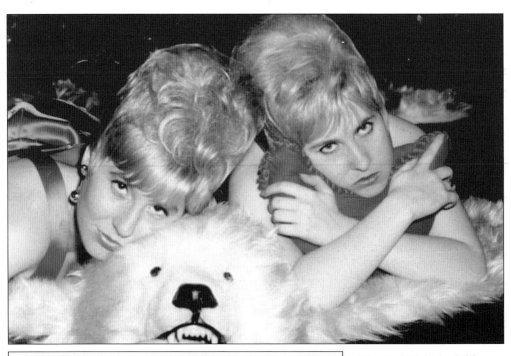

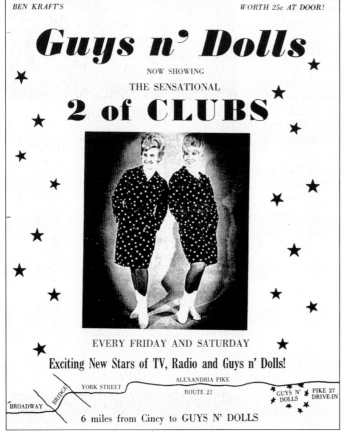

The 2 of Clubs look like twins as they peer up from a faux bearskin rug in this c. 1964 photograph. Linda Parrish (left) and Patti Valentine recorded pop songs for producer Carl Edmondson at Fraternity Records. Their soaring vocals made them popular attractions at the Guys 'n' Dolls nightclub, operated by Ben Kraft in northern Kentucky, six miles from Cincinnati. Edmondson discovered the group when his band, the Driving Winds, started backing the women. Guys 'n' Dolls was one of Greater Cincinnati's most popular nightclubs for young people. In the flyer, Parrish and Valentine are dressed in matching polka dot outfits with white go-go boots—stylish attire for the time. (Rusty York.)

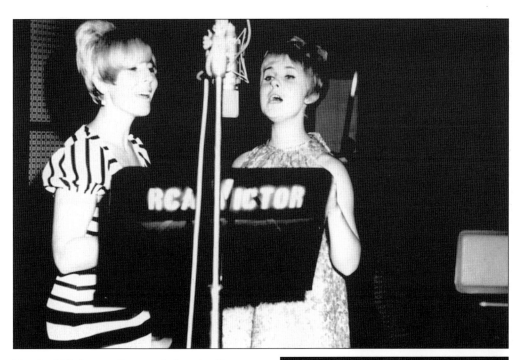

The 2 of Clubs usually recorded at the King Records studio in Cincinnati, but during this c. 1967 recording session they were at the RCA Studio in Nashville. The WSAI weekly record survey, distributed at hops and area record shops, shows the group's new record, "Walk Tall," listed at No. 2, after only two weeks on the chart. The year was 1966. "Walk Tall" would become the group's biggest hit, although it was much more successful in the region than across the nation. Also listed on the WSAI chart is another Cincinnati band, the Strangers in Town, produced by Cincinnati resident Herman Griffin. The WSAI chart shows how local radio stations once supported local artists. (Rusty York.)

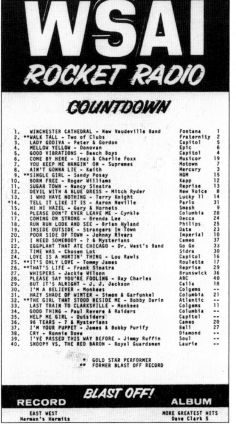

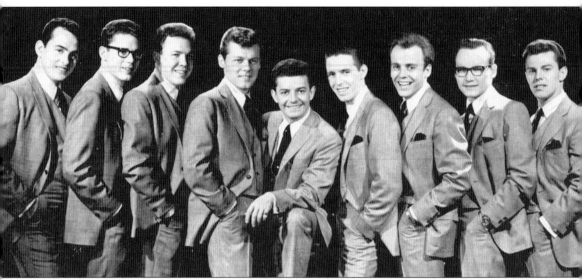

The Casinos stand for a publicity photograph after their top 10 hit, "Then You Can Tell Me Goodbye" in 1967. By then, the band already was a popular nightclub and party band in Cincinnati and had been together for nine years. Their neat appearance was sincere. "I believe the public wants the clean look to come back," lead singer Gene Hughes told columnist Earl Wilson. The Casinos toured nationally on the strength of their soulful hit, on which the group effectively combined horns and organ. By the time their album was released, the five-member group had expanded to nine. They are, from left to right, Pete Bolton, Michael "Mickey" Denton, Bob Armstrong, Ray White, Gene Hughes, Joe Patterson, Tom Mathews, Bill Hawkins, and Glen Hughes. (Bob Armstrong.)

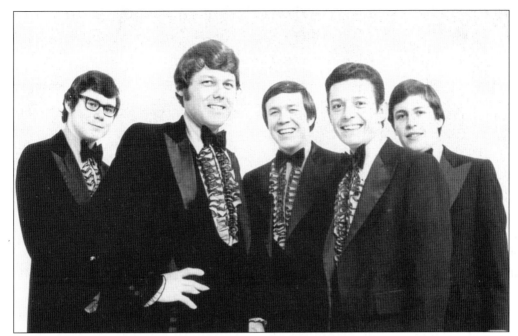

The Casinos of around 1969 show their concession to changing times—a little longer hair. The group wore tuxedos because they performed in Las Vegas and in nightclubs. The band was also serious about appearance. Members are, from left to right, Mickey Denton, guitar; Ray White, bass; Bob Armstrong, keyboards; Gene Hughes, lead vocals; and Dennis Feicke, drums. (Bob Armstrong.)

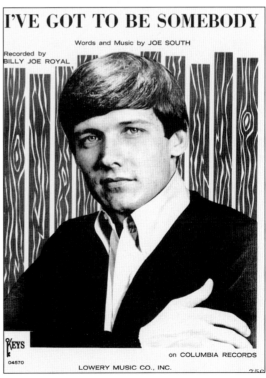

Georgia native Billy Joe Royal was singing full time at Castle Farm and other Cincinnati clubs when his record "Down in the Boondocks" broke nationally. The hit led to "I Knew You When," "I've Got to Be Somebody," "Hush," and other hits. He often returned to perform at the Inner Circle in Cincinnati and the Tiki Club in Colerain Township with his band, the Royal Blue. (Author's collection.)

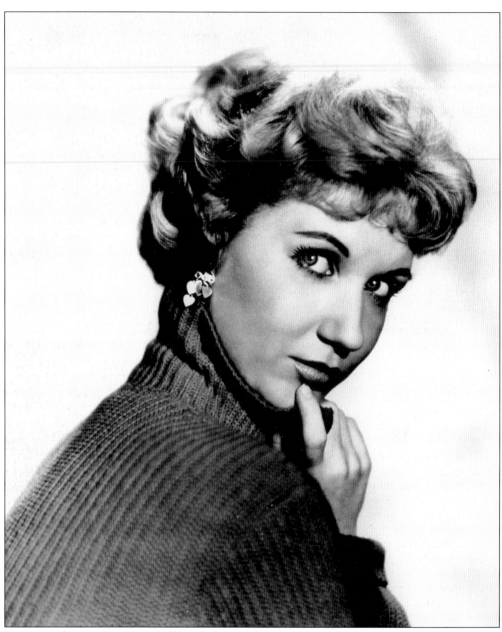
Petite vocalist Jo Ann Campbell made her mark as a 1950s recording artist who appeared in disc jockey Alan Freed's live rock-and-roll shows. She recorded an answer record called "(I'm the Girl On) Wolverton Mountain." By 1964, however, she had married Troy Seals, a Fairfield, Ohio, bass player who had toured with Lonnie Mack and other Cincinnati acts. Campbell and Seals moved to Cincinnati, formed their own white soul band called the Cincinnati Kids, and started performing at the Inner Circle near the University of Cincinnati. The band was one of the hottest acts in town. When Campbell became pregnant, she dropped out, and the band evolved into the Dapps. (Author's collection.)

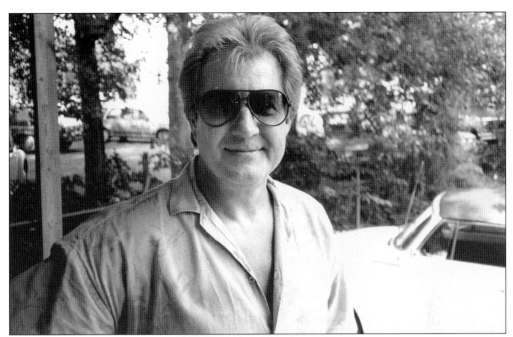

In this 1986 photograph, Troy Seals stands behind his song publisher's office in Nashville. By then, he had established himself as one of Music City's top writers. He moved there from Cincinnati in the early 1970s to write and play on recording sessions, including Dobie Gray's "Drift Away." Seals, now a member of the Nashville Songwriters Hall of Fame, wrote the country hits "Seven Spanish Angels" and "Lost in the Fifties Tonight." Pictured below is Jo Ann and Troy's nationally charted soul record, "I Found a Love Oh What a Love," from 1964. "People thought we were black until we showed up and they saw for themselves," Seals said. (Author's collection.)

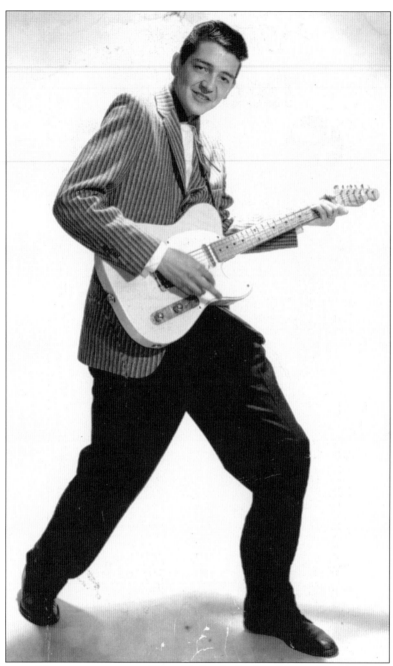

In this campy publicity picture, singer Rusty York of suburban Mount Healthy looks as though he could step right out of 1959. York is a master of the guitar. He recorded the rockabilly cult record "Sugaree" for Chess Records of Chicago and landed on Dick Clark's *American Bandstand*. In an unusual rockabilly combination, York used horns on the record. After it started climbing the *Billboard* charts, York was asked to perform at a rock concert at the Hollywood Bowl. He came back to reality fast, however, when he opened his first royalty check. "They must have charged me for every ice cube," he said. York went on to open Jewel Recording in Mount Healthy and play on many recording sessions. (Rusty York.)

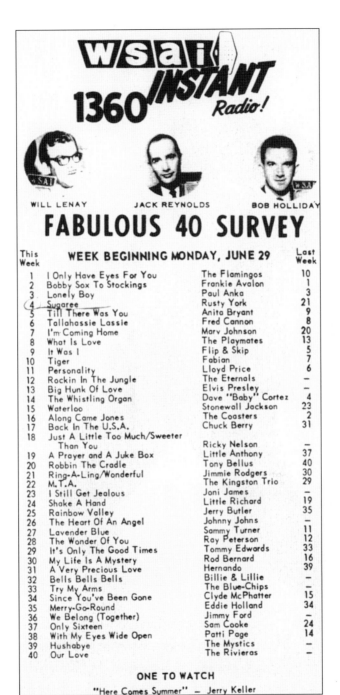

Back home in Cincinnati, WSAI started playing "Sugaree" to a wild reaction. On June 29, 1959, the record shot up the station's weekly chart to No. 4. Rusty York, the singer who had previously been known mainly in country nightclubs around town, was suddenly known across the whole city. He was a rock star! He saw his name on the station's chart with Frankie Avalon and other artists with whom he had recently met at rock-and-roll shows. As he was driving down Hamilton Avenue in Mount Healthy one day, he heard a familiar sound. A girl was listening to "Sugaree" coming over her car radio. "What a thrill," York said. (Author's collection.)

This poster beckons music lovers to an outdoor concert in the early 1990s, when guitarist Lonnie Mack was returning to the recording scene on the Alligator label from Chicago. Since 1963, when he hit with the instrumental "Memphis," he had been traveling from gig to gig. He still played his Flying V, serial No. 7, which he bought for $300 in 1958. In an automobile accident once, the guitar flew out of his car and into a field. When he picked it up, it was still in tune. "The guitar is more famous than I am," he said. (Author's collection.)

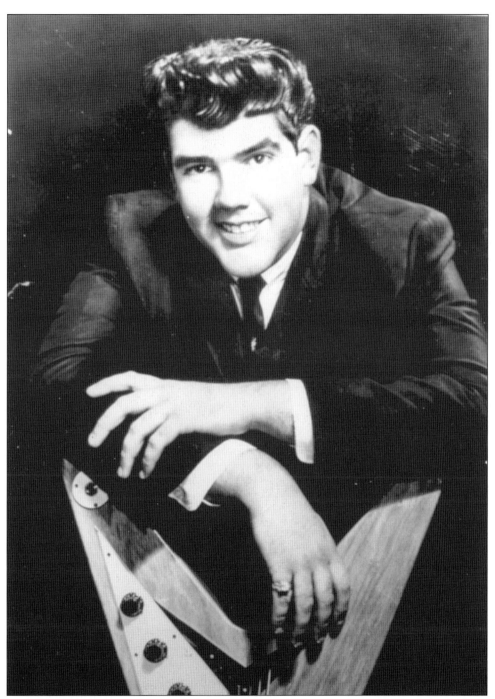

Lonnie Mack grew up in Aurora, Indiana, as Lonnie McIntosh. At age 14 he started playing professionally around Cincinnati, and in 1963, Fraternity Records released his single "Memphis," his interpretation of the Chuck Berry song. He followed that hit with another instrumental, "Wham!" Mack was the Cincinnati sound. He combined the blues, country, and rock to forge his own music. He was also the missing link between 1950s rockers and Eric Clapton, Stevie Ray Vaughan, and other guitarists who followed. (Author's collection.)

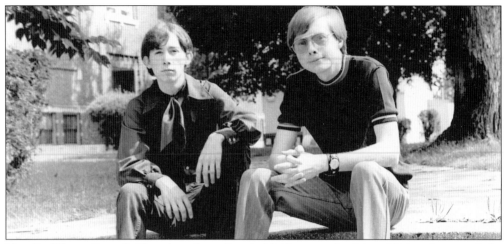

Vocalist Wayne Perry (left) and producer Randy McNutt pose in this publicity photograph for Avco-Embassy Records in 1970. McNutt found Perry, a blue-eyed soul singer from Hamilton, and recorded him in Cincinnati using the Perry's band, the Young Breed. Perry started singing professionally at age 14. He and McNutt leased the soul-rock single "Mr. Bus Driver" to the New York label. Perry and McNutt formed a production company that made a number of soul, rock, and country records in Cincinnati. Later Perry wrote hits for the Back Street Boys, Lorrie Morgan, and other acts. Below is an advertisement for the Half-Way Inn in Butler County, where Perry was performing with the Chamberly Kids when he recorded several other early records. (Author's collection.)

HALF-WAY INN
RTE. 4
Presents
WAYNE PERRY
and the
CHAMBERLY KIDS

Four
HIT MEN

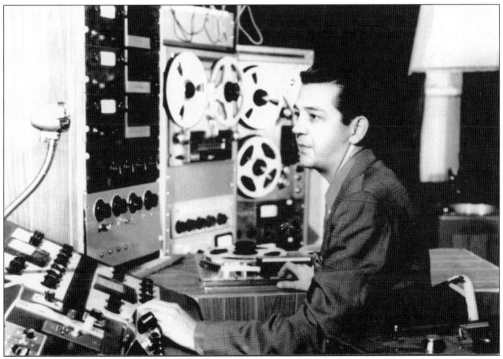

Rusty York plays a tape in his Jewel Recording Studio in Mount Healthy around 1964. In 1961, York founded the studio after performing in Cincinnati and across the nation. He became involved in the local music industry, serving gospel, country, and rock clients. His own label, Jewel Records, has featured artists such as guitarist Lonnie Mack and York. York and his wife, Linda, continue to operate Jewel at its present location on Kinney Avenue. (Rusty York.)

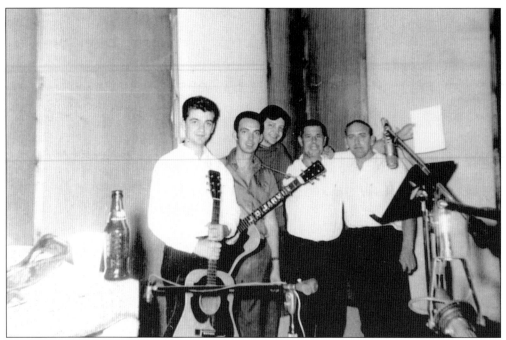

Rusty York and a rhythm band take a break at a Jewel recording session around 1963. He stands behind the group, smiling, while guitarist J. D. Jarvis stands on York's left. On the far left is bassist Herman Cress, who played on dozens of Cincinnati country and rockabilly sessions in the 1950s and 1960s. (Rusty York.)

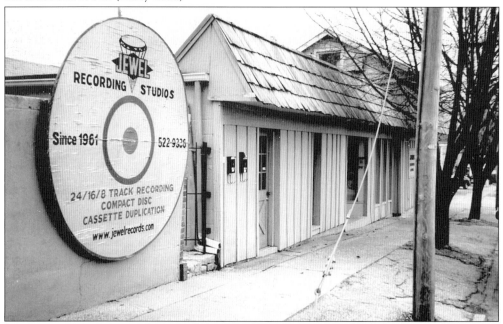

Jewel Recording on Kinney Avenue in Mount Healthy features a large wooden disc in front that serves as a "billboard." At Jewel, Lonnie Mack recorded two of his seminal 1960s albums for Elektra Records. Rusty York, Troy Seals, and other Cincinnati musicians played on the sessions. (Author's collection.)

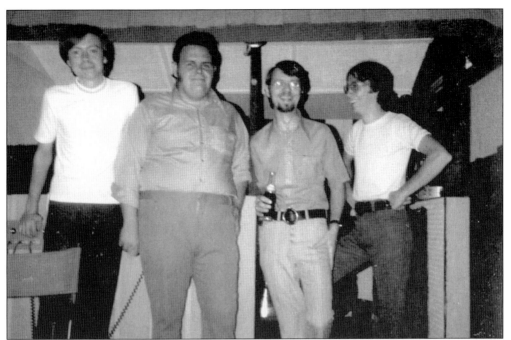

Cincinnati country singer Ron Sweet (second from left) takes a break at Counterpart Creative Studios in Cheviot during the recording of his single "Poor Side of Town," produced by Randy McNutt (far left) and Wayne Perry (far right) in 1973. Standing next to Sweet is engineer and drummer Gene Lawson, who provided the beat for Lonnie Mack's "Memphis" and created the Lawson Microphone in Nashville. (Author's collection.)

Jerry Springer snaps his fingers during rehearsal in the Jewel Recording control room while Rusty York (far left) ponders the song. On the far right, wearing a cowboy hat, engineer and fiddle player Rollin Bennett Jr. gives an encouraging word. Springer, once the mayor of Cincinnati, made several records in the 1970s. (Author's collection.)

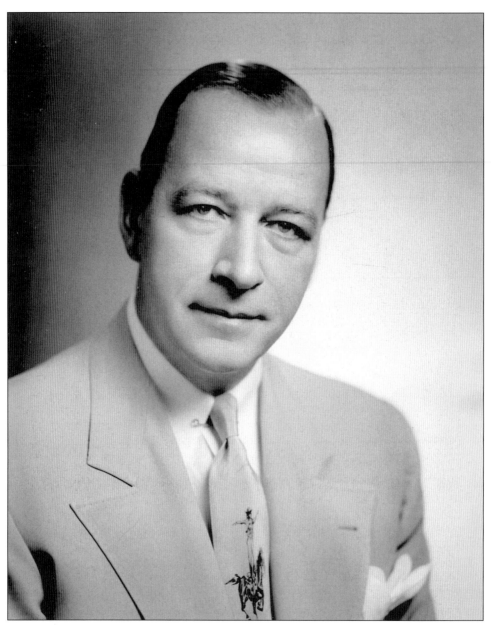

Harry Carlson, a former big band horn player from Nebraska, came to Cincinnati in 1933. Eventually he opened a portrait photography studio and dabbled in songwriting. In 1954, he wrote "Dream Girl of Phi Kappa Alpha" for a University of Cincinnati sorority and recorded it with local singer Dick Noel. To Carlson's surprise, the records that he pressed continued to sell, so he made more. By 1956 he had a national hit, "Ivory Tower" by Cathy Carr, followed by "So Rare" by Jimmy Dorsey in 1957. Carlson continued to make hits with the "All-American Boy" by Bill Parsons (really Bobby Bare), "Memphis" by Lonnie Mack, and "Then You Can Tell Me Goodbye" by the Casinos. For years he operated out of his suite—nothing but a desk, a telephone, and an old tape recorder—in the Sheraton Gibson Hotel. But that was all he needed, for Carlson was a master record promoter who personally knew most of the major disc jockeys across the country. (Dale Wright.)

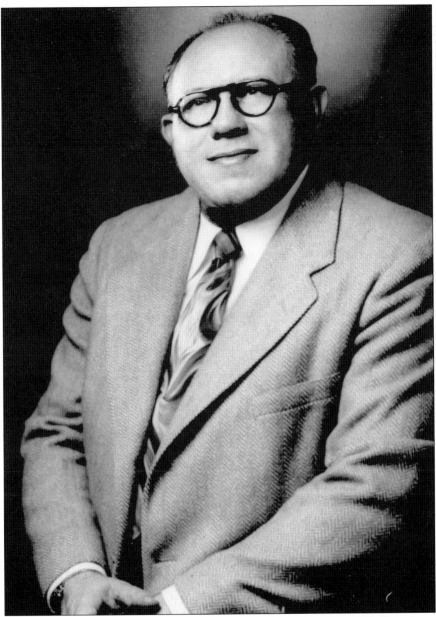

Cincinnati native Sydney Nathan founded King Records in 1943. By 1949, King was one of America's largest independents, selling primarily rhythm and blues and country records. Nathan's label recorded country stars Cowboy Copas, Hawkshaw Hawkins, Wayne Raney, the Delmore Brothers, Bonnie Lou (of WLW), and many others. In addition, Nathan signed rhythm and blues acts such as Wynonie Harris, Hank Ballard and the Midnighters, and Bull Moose Jackson. Nathan worked in an old building at 1540 Brewster Avenue in Evanston, where it was not unusual to find black and white artists following each other for recording sessions. Nathan pioneered the use of integrated session bands and offered blacks jobs at a time when they were not afforded as many opportunities. He also formed one of the nation's most successful song publishing companies, Lois Music, which held the copyrights on hits such as "The Twist," "Talk to Me," and "Kansas City." (Zella Nathan.)

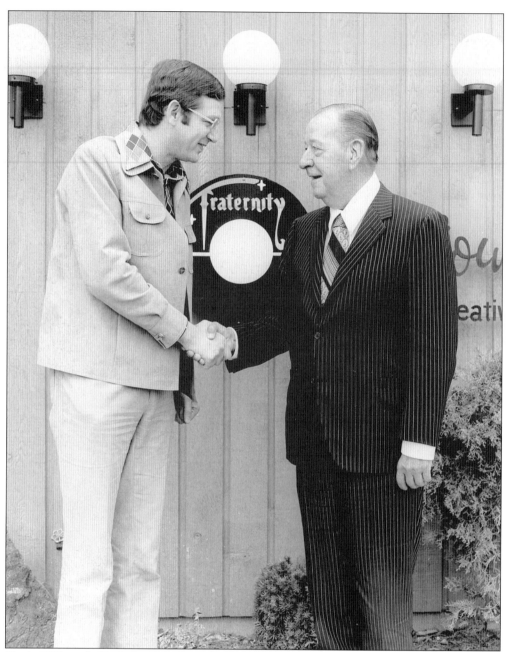

Shad O'Shea (left) shakes hands with Fraternity Records founder Harry Carlson on the completion of a deal to sell the company to O'Shea. After the contract was signed in 1975, Carlson retired to Florida and O'Shea, a former WCPO Radio disc jockey, moved the company from downtown Cincinnati to his Counterpart Creative Studios on Applegate Avenue in nearby Cheviot. The transfer marked the end of Carlson's 20-year ride in the music business. Fraternity has operated continuously. (Shad O'Shea.)

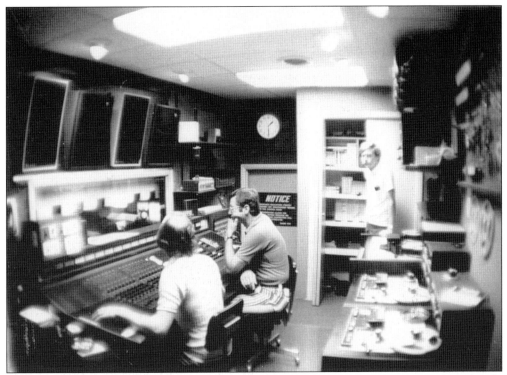

O'Shea ponders a playback in the Counterpart Creative Studios control room in 1971, shortly after it opened. Sitting with him is an engineer. Counterpart started as a 16-track studio and expanded to 24 before closing in 1991. A number of local personalities and performers recorded there: hit country songwriters Bobby Borchers and Mike Reid, an R&B band called Sun, and television host Bob Braun. (Author's collection.)

The former King Records building looks somber in this 1990s photograph. It was taken shortly before a city-sanctioned committee considered the merits of adapting the building into a music museum. The author was a member of the group, which invited James Brown to tour the facility in which he once recorded. Upon his arrival, Brown was saddened to learn that the cost of renovation would be too great. (Author's collection.)

To most people in the region, Zeke Turner (left) was the funny man in the duo the Turner Brothers on the *Midwestern Hayride*. To music industry insiders, he was one of the most gifted country guitarists in the nation who played on Hank Williams's sessions and many for King Records. By day, Turner drove a truck. "You don't think I make enough money on the *Hayride* to survive, do you?" he once told musician Rusty York. (Author's collection.)

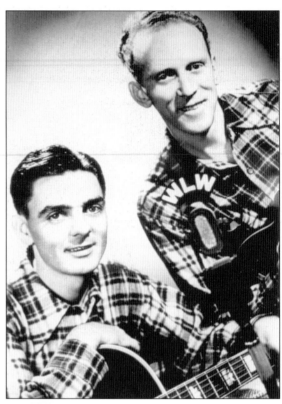

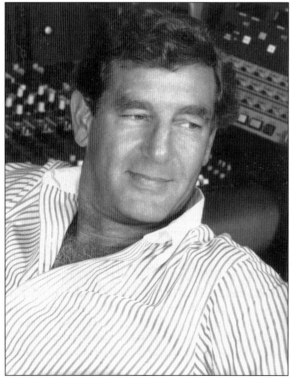

Shad O'Shea was Cincinnati's busiest independent producer from the early 1960s through the 1980s, recording acts for RCA Victor, Columbia, Monument, Capitol, Mercury, and other national labels. But his most interesting contribution came from his own novelty records. They included "Beep," a satire on answering machines; "McLove Story," about a guy who falls in love in McDonald's; and "Colorado Call," based on the 1970s citizen-band radio craze. (Shad O'Shea.)

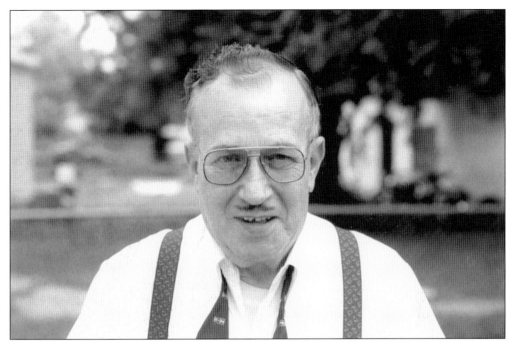
Larry Short founded Ruby Records in Hamilton in the 1950s. The company became an underground success with rockabilly and country music. He formed a country stage show with his performers and toured the region. Ruby artists included producer Ray Pennington and Bill Watkins. Today some Ruby singles are selling for $150, with most intense interest coming from Europe. (Author's collection.)

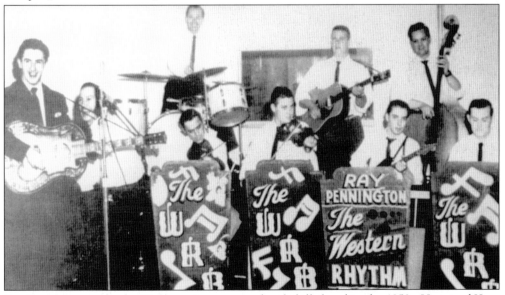
Ray Pennington started a Cincinnati country and rockabilly band in the 1950s. He joined King Records and ended up as an artist and repertoire (A&R) man. Pennington sang both types of music for Lee and other local labels, and while at King he recorded under his own name and as Ray Starr. He left for Nashville in the 1960s and became a successful producer and songwriter. (Author's collection.)

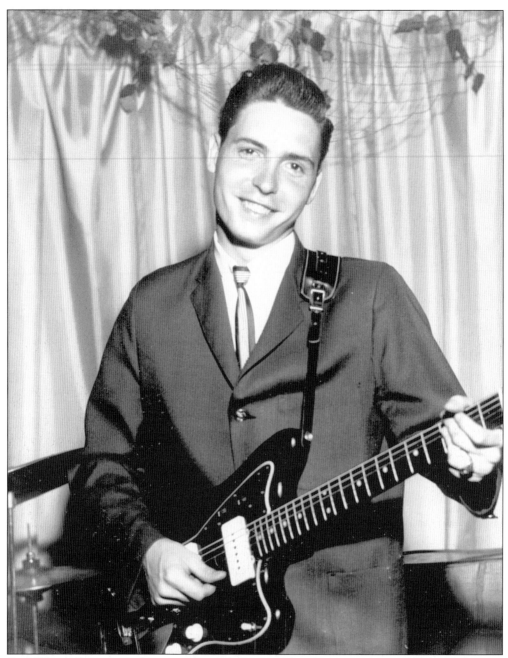

Carl Edmondson strums his guitar in this photograph taken in 1961, just before he became the hottest independent record producer in Cincinnati. Edmondson produced four nationally charted singles for Fraternity, including "Memphis" and "Wham!" by Lonnie Mack and "Walk Tall" by the 2 of Clubs. He also produced Bob Braun's regional hit "Sweet Violets" and other local records. "I did the production thing just to mess around," he recalled. "Then things started happening locally with the records. I purposely stayed away from the road so that I could produce independently. Cincinnati was a happening place then. King and Fraternity were both going strong." He continued to play music with his band, the Driving Winds. (Carl Edmondson.)

Five
AMONG THE STARS

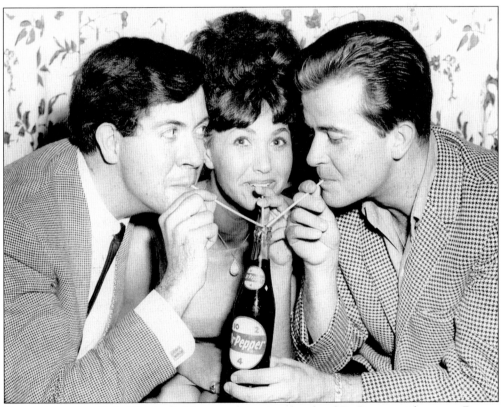

Singer-songwriter Dale Wright (left) pretends to sip a bottle of Dr Pepper with actress Donna Loren and rock impresario Dick Clark in this early-1960s publicity photograph. Wright, a Middletown native who recorded in Cincinnati and performed there regularly, participated in many of Clark's traveling rock-and-roll shows during that decade. He recorded for Fraternity Records. In the 1980s, he became a disc jockey in Lexington, Kentucky. (Dale Wright.)

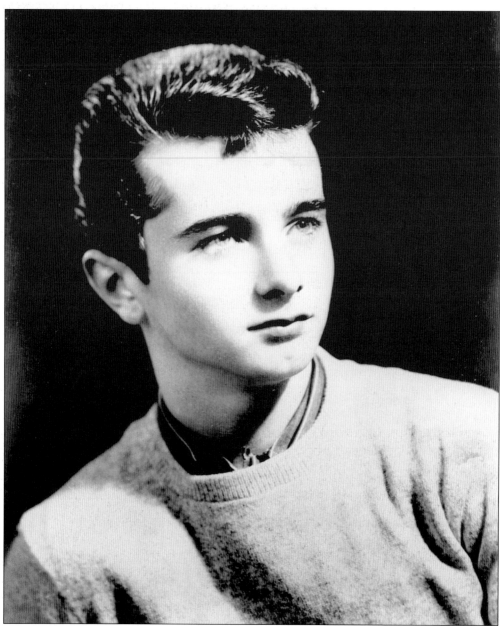

Carl Dobkins Jr., a pop singer from Clifton Heights, started playing guitar at age nine, continuing a family tradition. While a student at Hughes High School, he wrote "Take Hold of My Hand" for his girlfriend, who did not even hear the song before Carl recorded an audition record. Gil Shepherd, a disc jockey at WKRC, liked it so much that he played it until it became a local hit. This led to a contract with Fraternity Records. When Dobkins was only a 17-year-old senior in 1958, he signed with the larger Decca Records. After graduating, he soon had a national hit, "My Heart Is an Open Book," which reached No. 3 on the *Billboard* pop chart in April 1959 and received national airplay for a total of 24 weeks. By that Christmas, he had another hit, "Lucky Devil," and by spring 1960, a total of four nationally charted records. (Author's collection.)

In 1958, Bobby Bare (right) and Bill Parsons stopped in Cincinnati en route from Ironton, Ohio, on their way to be inducted into the U.S. Army in Kentucky. On the way they stopped at King Records's studio to record a few songs. After they left, a studio employee sent a copy of Bare's recitation song "All-American Boy" to Harry Carlson at Fraternity Records. But the engineer inadvertently switched the names on the tapes, and Carlson credited the rockabilly record to Parsons. "Bill started getting all these offers to perform," Bare said. "He knew that All-American Boy was a rappin' record. You could hardly lip-sync it. It was my story, too." Later Carlson released other records by Bare and Parsons, but this time he got their names straight. (Author's collection.)

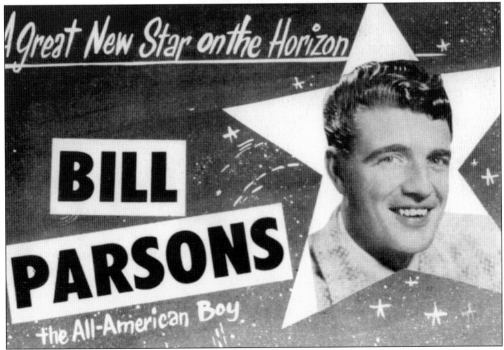

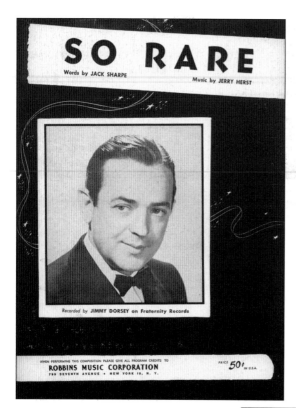

Fraternity Records released saxophonist Jimmy Dorsey's "So Rare" on January 5, 1957. Nothing happened. Owner Harry Carlson called disc jockeys at every radio station in Cincinnati. "I asked them to support 'So Rare' just for two weeks," he said, "and if it did not go over I would never ask another favor of them." As a result, Fraternity sold 30,000 copies locally in four weeks. (Author's collection.)

The McGuire Sisters—Phyllis, Dorothy, and Christine—grew up in Middletown in Butler County. They became one of the most successful pop singing groups of the 1950s, amassing 22 songs on Billboard's charts from 1955 to 1959. Their biggest hits included "Sincerely," "He," "Sugartime," and "May You Always." (Author's collection.)

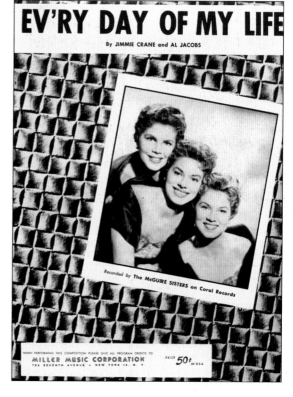

Cathy Carr of California recorded the pop ballad "Ivory Tower," the first big hit for Cincinnati's Fraternity Records. It reached No. 2 on *Billboard*'s pop chart on March 17, 1956, and set off a round of cover versions in pop, R&B, and country music. (Author's collection.)

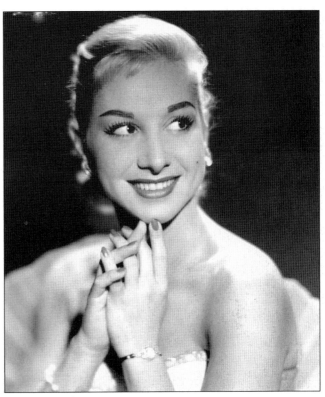

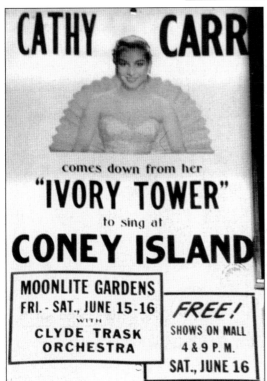

Coney Island amusement park in Cincinnati promotes a Cathy Carr concert at its Moonlite Gardens. She performed that spring with the Clyde Trask Orchestra. (Author's collection.)

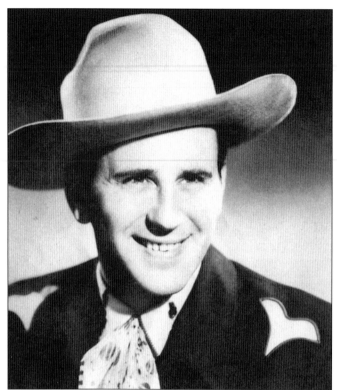

Frank "Pee Wee" King of Louisville performed in Cincinnati many times with his Golden West Cowboys and played on the staff at WLW-T from 1953 to 1954. He recorded for King Records from 1945 to 1946. King, famous for "The Tennessee Waltz," once hired Cowboy Copas to sing for his band. (Author's collection.)

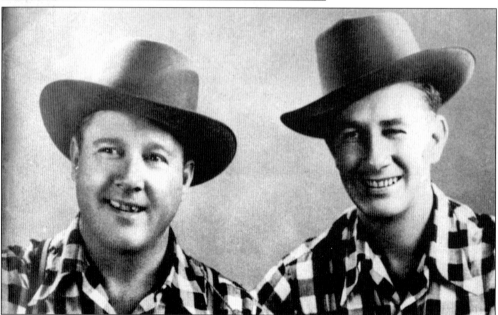

The Delmore Brothers performed on WLW and recorded for King Records. They were a seminal country band of the 1940s. The brothers grew up in Alabama and learned to play guitar and fiddle early in life. They played on the *Grand Old Opry* in the 1930s. For King they made three top 10 country hits, including the No. 1 "Blues Stay Away From Me." It was recorded in Cincinnati. (Author's collection.)

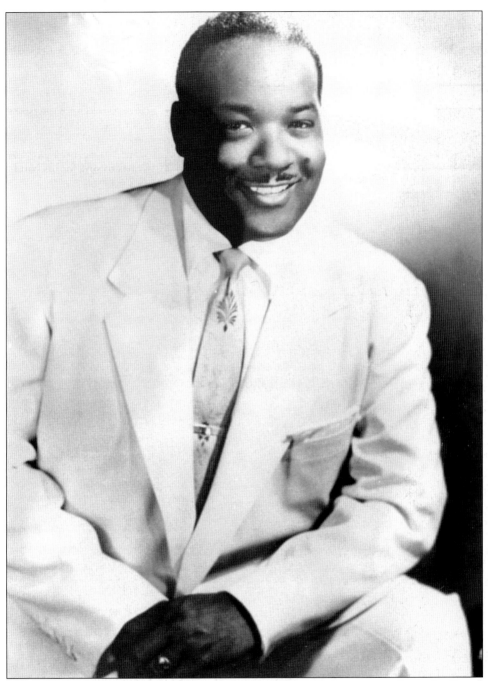

While keyboard player Bill Doggett and his combo were performing one night at the Scene, a nightclub in Lima, Ohio, they started jamming for the fun of it. They refined the same riffs over the next few weeks until they came up with an instrumental called "Honky Tonk (Parts 1 & 2)." Featuring Clifford Scott on sax, Doggett's group recorded the song for King Records. It turned into an unlikely monster hit that grabbed radio listeners. By that time Doggett, a Philadelphia native, was a veteran performer, having played for Lucky Millinder, the Ink Spots, Louis Jordan, and others. This photograph shows Doggett in the early 1960s. (Author's collection.)

Sydney Nathan discovered Harold "Hawkshaw" Hawkins at a radio station in West Virginia. Recording for Nathan's King Records, Hawkins became a country star in the late 1940s with "Pan American" and "Dog House Boogie." Hawkins died in the March 5, 1963, plane crash that also killed performers Patsy Cline, Cowboy Copas, and Randy Hughes near Camden, Tennessee. (Author's collection.)

Tennessee native Kenny Roberts performed on the *Midwestern Hayride* in the late 1940s and early 1950s. He was known for his yodeling and engaging smile. His first big hit was "I Never See Maggie Alone." He placed four hits on the country charts in 1949 and 1950 and was a popular performer on local television and radio. (Author's collection.)

Most people think of Roy Rogers as a California movie star and singer, but he was born Leonard Franklin Slye in Cincinnati in 1912 and grew up in Scioto County, about 85 miles east of Cincinnati. He moved to California in 1930 and performed with the Hollywood Hillbillies, Rocky Mountaineers, and Texas Outlaws. In 1938, he made the first of his 91 films, *Under the Western Stars*. (Author's collection.)

The Mills Brothers—John Jr., Herbert, Harry, and Donald—grew up in Piqua, Ohio, and came to WLW as featured performers. For years they appeared in films and on national radio shows. When John Jr. died in 1936, his father replaced him for the next 20 years. They recorded two of Hamilton, Ohio, composer Johnny Black's songs, "Paper Doll" and "Who'll be the Next One." (Author's collection.)

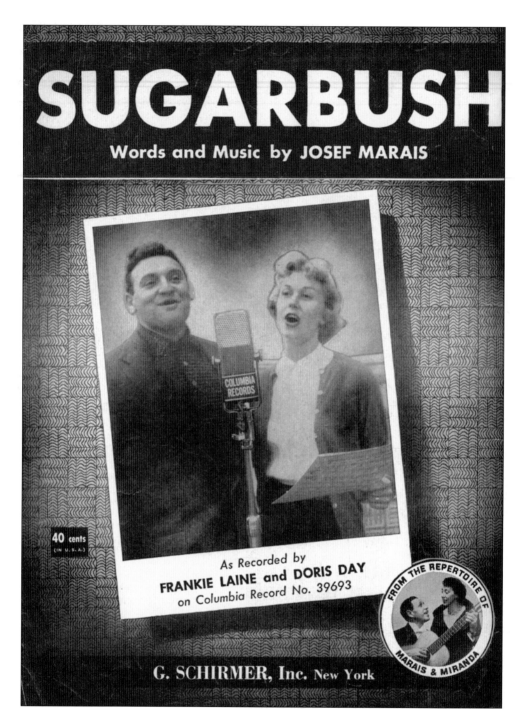

Doris Day (born Doris von Kappelhoff) and Cincinnati do not seem to fit in the same sentence, but she grew up in the city as one of its German Americans. Kappelhoff sang on WLW and performed with Barney Rapp's big band before joining the famous bandleader Les Brown. Her biggest hit record came in 1956, "Whatever Will Be, Will Be (Que Sera, Sera)," from the film *The Man Who Knew Too Much*. By then her film career was also rolling. She is best remembered for her romantic comedies with stars such as Rock Hudson. (Author's collection.)

Cincinnati's musician pool was once so deep that guitarist Chet Atkins backed up singers on WLW with Merle Travis and other expert pickers. But Atkins did not stay too long. He backed up performers in other cities and eventually stayed in Nashville, where he recorded instrumental albums and ran the RCA Victor branch. (Author's collection.)

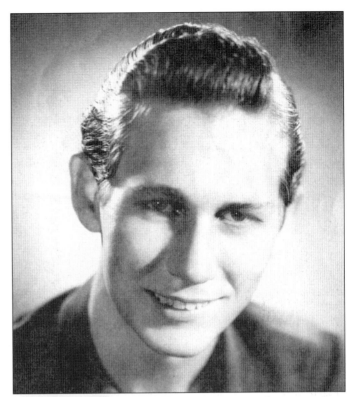

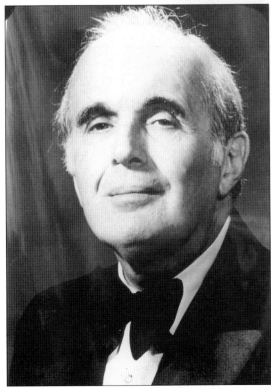

Bert Farber was not a national star in the 1950s, but the Fraternity Records artist was popular locally. His theme song, "Fountain Square," was easily recognized, and his big band was in demand for years. He often performed at Coney Island's Moonlite Gardens. (Author's collection.)

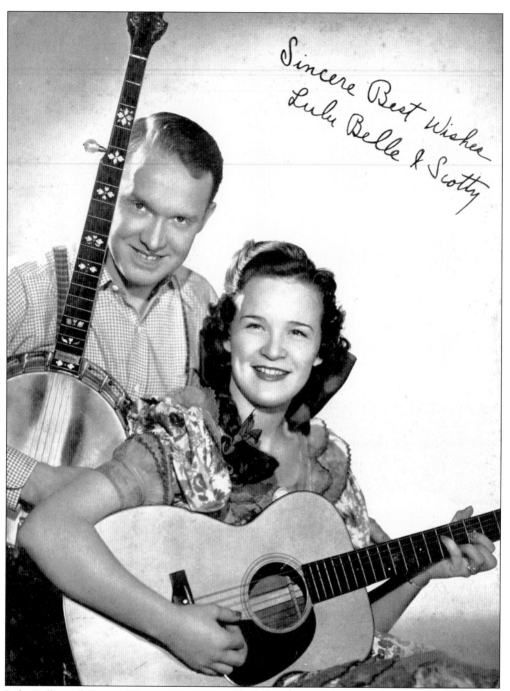

Lulu Belle and Scotty Weisman, a nationally known husband and wife team, performed on WLW's *Boone County Jamboree* in the 1940s. They were among the elite performers of early country music, and their presence on WLW shows how dedicated the station was to broadcasting good music. (Author's collection.)

Cincinnati songwriter Harry Carlson discovered pop vocalist Dick Noel in the mid-1950s. Noel became the first artist to record for Carlson's new Fraternity Records. The popular performer sang on local radio and performed a number of regional hits for the company. In those days, a talented performer like Noel could establish himself locally and work for years without having a national hit. (Author's collection.)

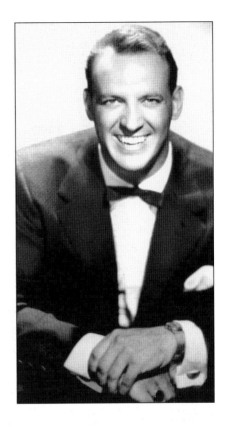

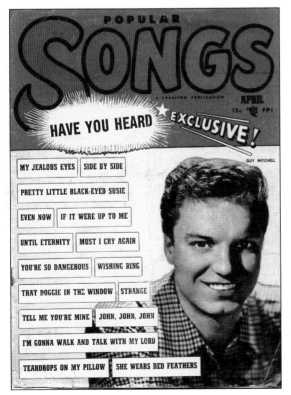

In 1949, Al Grant started recording for King Records. He made five singles—all flops. As Guy Mitchell, he went to Columbia Records and recorded a string of hits, including the No. 1 "Singing the Blues." (Author's collection.)

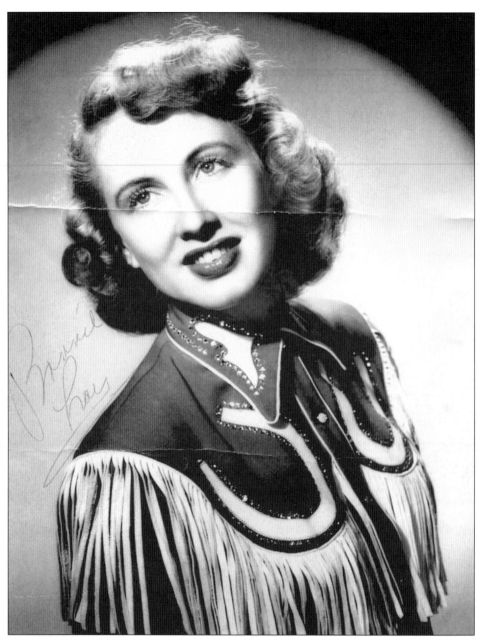

When Bonnie Lou was singing and yodeling on the *Midwestern Hayride* and other WLW shows in 1955, everyone knew she was country all the way. Everyone, that is, except the producers over at King Records. They had already recorded a couple of big country hits for her, and in 1955, they decided to cash in on the new teenage music by turning her into an unlikely rockabilly act. She never felt comfortable with the role, but her hit "Daddy-O," written by colleagues Charlie Gore and Louis Innis, peaked at No. 14 on the *Billboard* pop chart. Later she recorded another rockabilly song called "Friction Heat" for Fraternity Records. In retrospect, it is hard to imagine the accommodating Lou singing live across the tristate area with other *Hayride* performers, and hearing anyone screaming, "Play Daddy-O!" But if anyone did request it, Lou probably sang it. (Author's collection.)

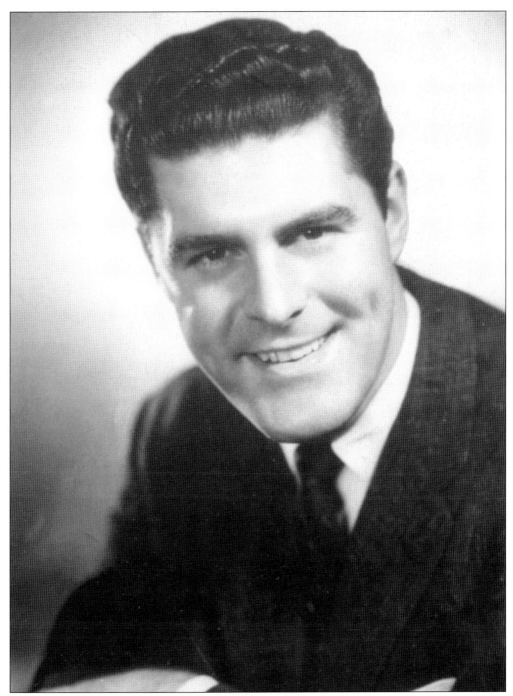

Bob Braun needs no introduction. He is fondly remembered for his days on the early television talk program the *Bob Braun Show*, which succeeded Ruth Lyons. But Braun had a second career as a vocalist. He recorded a number of singles and albums for national and local companies, and he had one national pop hit, "Till Death Do Us Part." Other locally popular records included "Sweet Violets." The northern Kentucky native was a fixture on local television for decades, and he often sang on his shows. (Author's collection.)

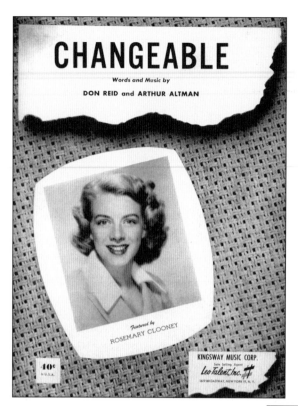

Rosemary Clooney began her career with her sister Betty on WLW. Later Rosemary turned to acting and starred in the classic *White Christmas* with Bing Crosby. Brother Nick Clooney has been an important local television personality, as both a news anchor and talk show host. (Author's collection.)

Barney Rapp, husband of WLW singer Ruby Wright, led a band called the New Englanders. He and Ruby settled in Cincinnati and performed at nightclubs throughout the region. He eventually founded a local travel agency. (Author's collection.)

Six
Country Days

Bonnie Lou wears her familiar cowgirl hat and western suit. She often wore such clothing on the *Midwestern Hayride*, on which she performed for over 20 years. One of WLW-T's longest-tenured stars, she was in demand at fairs and other venues for years. She was a multitalented performer who could easily handle pop, country, and gospel music, and then slide into a comic routine. (Author's collection.)

**JIMMIE SKINNER PRESENTS
A BIG COUNTRY MUSIC JUBILEE
SUNDAY, MAY 18, 1958**

SHOWS AT 2 AND 5 P.M.

OPENING DAY—VERONA LAKE RANCH, VERONA, KY.

5 Miles West of Walton, Ky., on Route 16 (25 Miles from Cincinnati)

RECORDING ARTISTS IN PERSON

Direct from Grand Ol' Opry

GEORGE JONES (Mercury-Starday Records)—"Color of the Blues"

(Direct from Bristol, Va.)

STANLEY BROS. (Mercury-Starday Records)—"No School Bus in Heaven"

JIMMIE SKINNER (Mercury-Starday Records)—"What Makes a Man Wander"
"I Found My Girl in the USA"

RAY LUNSFORD (Mercury-Starday Records)—"Carroll County Blues"—"Sheila"

CONNIE HALL (Mercury-Starday Records)—"I'm the Girl in the USA"
"We've Got Things in Common"

RUSTY YORK (Mercury-King Records)— "Dixie Strut" (5-String Banjo)
"Peggy Sue"

SKEETER DAVIS (RCA Victor Records)— "Lost to a Geisha Girl"
"I Need You All the Time"

JIMMIE LLOYD (Roulette Records)—"You're Gone Baby"
"I Got A Rocket in My Pocket"

DONNIE BOWSER (Fraternity Records)—"Stone Heart"—"I Love You Baby"

BOBBY GROVE (King Records)—"Mocking Bird Sings at Midnite"

RALPH BOWMAN (Excellent Records)—"Tragedy of School Bus 27"

and Many Others

Jimmie Skinner Will Celebrate His 7th Anniversary on
WNOP (740 on Dial)

Also Sixth Anniversary of Jimmie Skinner Music Center

**MANY FREE RECORDS AND ALBUMS GIVEN AWAY
PLUS MANY DOOR PRIZES**

Picnic Tables Fishing Kiddie Rides Refreshment Stands

ADMISSION AT GATE 75c

Jimmie Skinner was more than a singer. He was an entrepreneur. In late 1955, he and his manager sponsored Cincinnati's first country music show in years (with the exception of WLW's shows). He brought in the Davis Sisters, Pee Wee King, and Natchee the Indian. This flyer depicts another successful Skinner show, from 1958. Its roster featured Rusty York and other country performers. (Rusty York.)

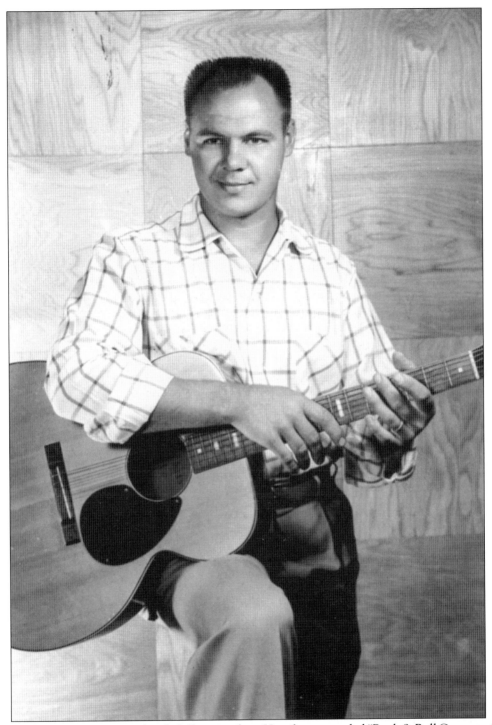

Emery Blades, a country and rockabilly singer from Hamilton, recorded "Rock & Roll Carpenter" and other songs for Ruby Records. Later he recorded for Jimmie Skinner's Arvis Records. Although he was not famous in 1958, today his records are collectors' items. He is a member of the Rockabilly Hall of Fame. (Author's collection.)

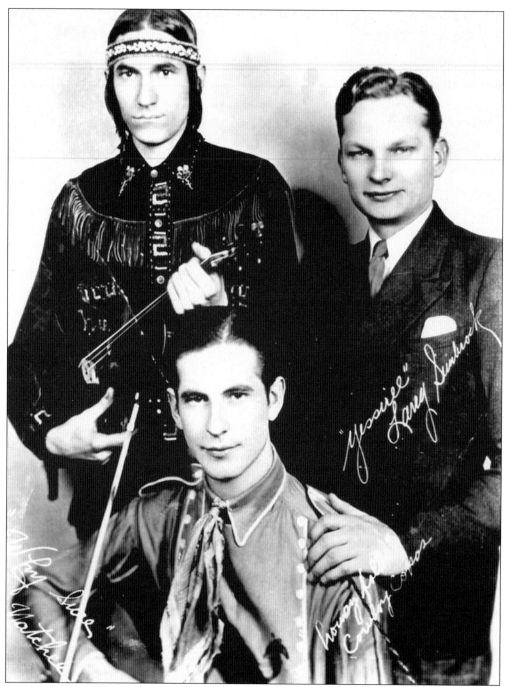

In this 1936 photograph, guitarist Lloyd Copas and fiddler friend Vernon Storer—called Cowboy Copas and Natchee the Indian by their manager—pose with fiddling contest promoter Larry Sunbrock. Eventually Copas started singing and the duo came to Cincinnati. Before they drifted apart, Copas and Storer performed around the Queen City. Minus Natchee, Copas later became a hit solo artist for King Records. (Author's collection.)

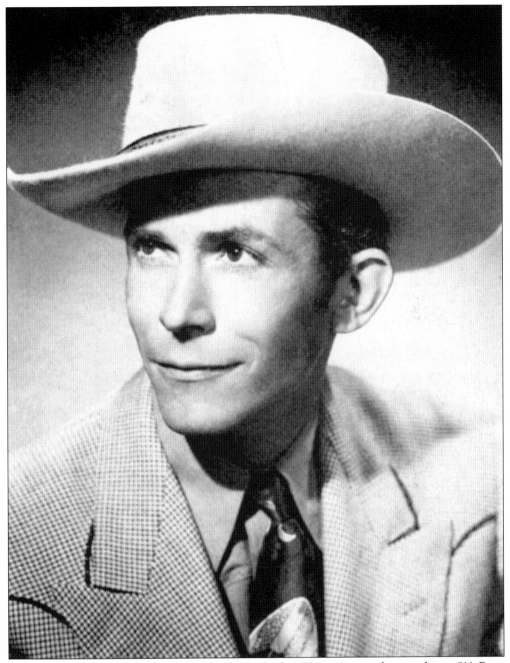

The legendary Hank Williams came to E. T. "Bucky" Herzog's recording studio at 811 Race Street in Cincinnati to record several tracks in 1949. He knew he could find talented country musicians in Cincinnati. He was not disappointed. At the sessions he cut the hit "Lovesick Blues," which manager Fred Rose had advised him not to record. He also recorded another now familiar song, "I'm So Lonesome I Could Cry." Zeke Turner played guitar on the session—and on at least 30 of Williams's songs. "I tell people that I recorded Hank Williams right here in Cincinnati and they don't believe me," Herzog said. "Cincinnati had more going for it than Nashville back in the days before Nashville's studio system developed." (Author's collection.)

Singer-songwriter "Orangie" Ray Hubbard knows how to boogie. The Cincinnati country performer was a pioneer rockabilly in the 1950s. He recorded "Sweet Love" for Dixie Records of Nashville when he was a young man in Barberville, Kentucky. He moved to Cincinnati to work in an automobile factory, and recorded for the local Lucky Records and later for King. "The establishment didn't accept me," he said. "And I had bad luck. A record called 'Big Cat' would have done something for me if Syd Nathan of King Records hadn't died just before it was to be released." Hubbard has continued to record over the years, however, and perform at rockabilly and country shows. He still shows audiences why he was one of Cincinnati's best early rockabilly singers. (Ray Hubbard.)

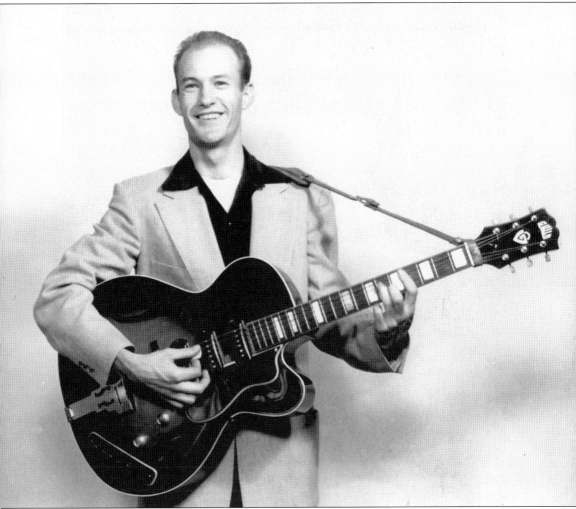

Bill Watkins, a native of Corbin, Kentucky, is a country and rockabilly singer-songwriter who recorded for the local Ruby, Lucky, and General Store record companies. His 1950s rockabilly single "Missed the Workhouse" is now a collector's item in Europe, selling for about $200. "We called it fast country before it was known as rock and roll," he said of the music. In the early 1960s, he wrote the ballad "Time Will Make You Pay" for country star Roy Acuff. Watkins worked in a paper mill by day, and at night wrote songs and performed. He opened his own Tip-Toe Recording Studio in the 1970s and served as engineer for other artists. In 1990, he finally arrived on the national country music charts with his original song "Cowboy." (Bill Watkins.)

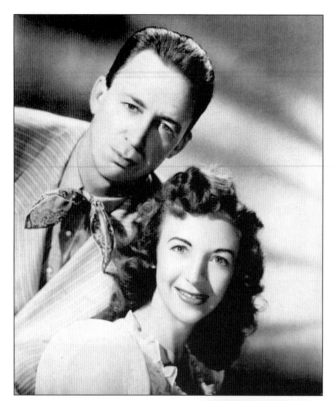

Otis W. "Joe" and Rose Lee Maphis performed on WLW's *Boone County Jamboree* in the 1940s, when the station appealed to rural residents. The "King of the Strings" was one of the nation's top country guitarists. He and Rose appeared on several television shows and series. (Author's collection.)

Because of his two-finger, right-hand style, Aubrey "Moon" Mullican was dubbed "the King of the Hillbilly Piano Players." He came from Texas and started recording for Cincinnati's King Records in 1948. He made several of his big hits in the company's Evanston studio. They included "New Pretty Blonde (Jole Blon)," "I'll Sail My Ship Alone," and "Mona Lisa." (Author's collection.)

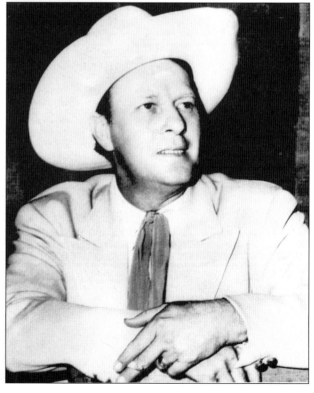

Hawkshaw Hawkins was born on December 22, 1921, in Huntington, West Virginia. He started working for local radio stations at age 15. After returning from World War II, he joined the *WWVA-Wheeling Jamboree* country music show. The King Records artist slumped through most of the 1950s. His big comeback hit, "Lonesome 7-7203," debuted on King three days before he died. He was married to singer Jean Shepherd. (Author's collection.)

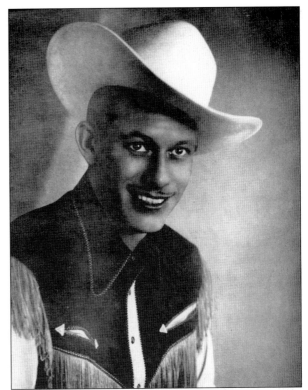

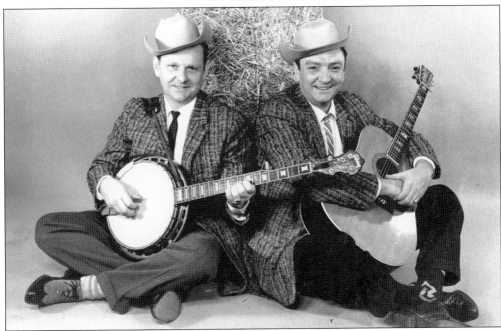

Although Virginia's bluegrass brothers Carter Glen and Ralph Edmond Stanley had been recording for Rich-R-Tone Records and other labels since 1946, they had never had a big country hit until they came to King Records. "How Far to Little Rock" arrived on the *Billboard* charts in March 1960 and eventually rose to No. 17. (Stephen Halper.)

Guitarist Louie Innis performed on WLW programs when he was not working as an A&R man at King Records. The writer-producer played on many of King's early hits and cowrote Bonnie Lou's rockabilly hit "Daddy-O." Eventually he left for Nashville and became a part of the first Music City "A-Team" of top pickers. (Author's collection.)

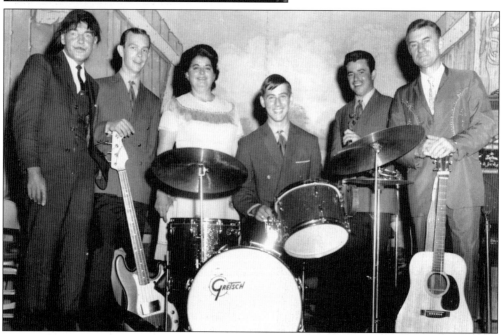

Doc Williams, a West Virginia country music performer, recorded and wrote songs for King Records. He once received a 3¢ songwriting royalty check from King founder Sydney Nathan. An amused Williams, who toured with his wife and band, framed the check and hung it on the wall of his office. (Doc Williams.)

In Cincinnati in 1943, country music enthusiasts could hear a fiddling and yodeling program. In those days, fiddling events were held all across the country. This one was held in Memorial Hall downtown. Cowboy Copas was on the list of performers. (Author's collection.)

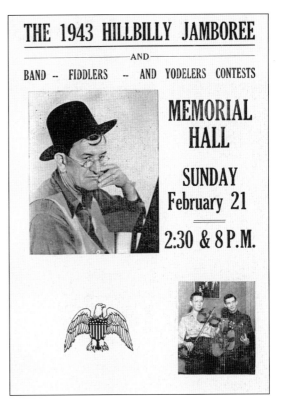

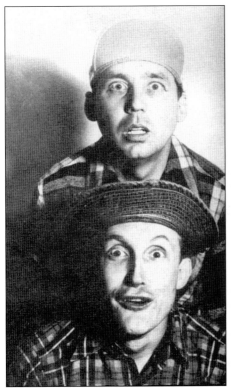

Country music comedians and musicians Homer and Jethro—Henry D. "Homer" Haynes on guitar and Kenneth C. "Jethro" Burns on mandolin—started working fairs and radio shows in 1932. As many other talented performers did, the duo ended up in Cincinnati. In 1949, they recorded a country hit called "I Feel That Old Age Coming On" for King Records. (Author's collection.)

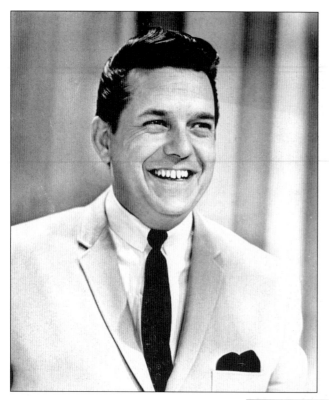

West Virginia vocalist Charlie Gore performed on the *Midwestern Hayride* and other local programs in the 1950s. He recorded for King Records. Eventually he settled in Fairfield, Ohio, and became a member of the Butler County Board of Elections. Through the 1970s he continued to perform at shows across Ohio, Indiana, and other states. (Steve Lake.)

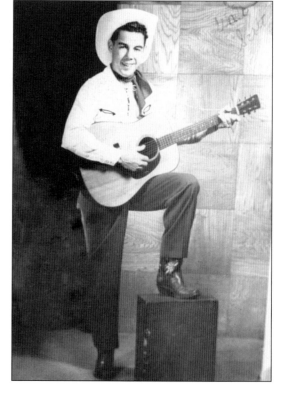

Walter Scott grew up in Pendleton County, Kentucky, where he and his five brothers performed at barn dances before World War II. After moving to the Cincinnati area, he wrote "Burning Bridges" for Jack Scott, a No. 3 *Billboard* hit in 1960. By day he worked at General Electric's jet engine factory in Evendale. He used to wear a jacket to work with the words "Burning Bridges" embroidered on the back. (Author's collection.)

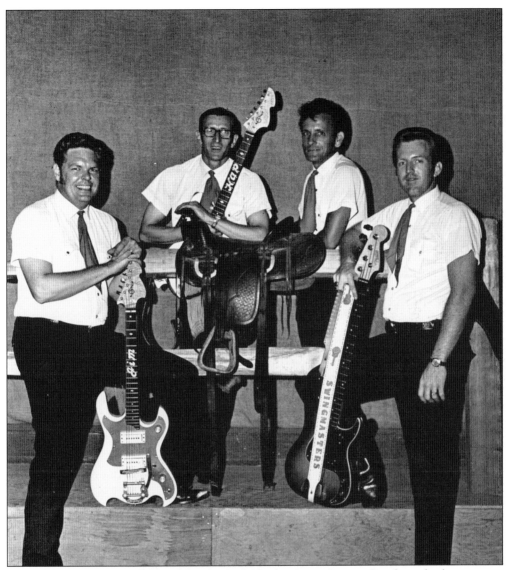

Steve Lake's band, the Swingmasters, backed Charlie Gore, Connie Smith, and other country stars over many years. In 1965, guitarist Jim Parsons of Fairfield (left) joined the band, which backed *Hee-Haw* and *Grand Ole Opry* performers. Lake, a jeweler from Franklin, toured the country in a silver bus. The Swingmasters became the staff band at the *WWWA Wheeling Jamboree* and at the Chautauqua performances in Ohio. In 1974, the Swingmasters and Smith closed the historic Ryman Auditorium in Nashville and then played the opening night at the new Grand Ole Opry House. Pres. Richard Nixon attended that performance. The Swingmasters consisted of (left to right) Parsons, Hap Hammond, Junior Dixon, and Lake. (Steve Lake.)

When Luke "Pappy" Tipton talked about country music, people listened. He was a longtime disc jockey on Fairfield's WCNW (appropriately, the call letters stood for country 'n' western). The National Association of Disk Jockeys once awarded him its DJ of the Year honor. Tipton also recorded for the Ruby label and others. For Ruby he sang the quintessential lonely man's anthem, "Empty Bottles and Cigarette Butts." For years Pappy Tipton was one of the unsung heroes of Cincinnati's country music scene. (Author's collection.)

Seven
SOUL SERENADE

If one wanted a tight soul sound on their record in the early 1960s, they hired the Charmaines, led by Gigi Jackson. They sang backup for artists at King Records and performed throughout the area. They appeared on Lonnie Mack's *Wham of That Memphis Man!* and recorded their own local hit, "What Kind of Fool Do You Think I Am?" for Fraternity. During the 1960s they also recorded for Columbia and others. Jackson later married producer Herman Griffin. (Mick Patrick.)

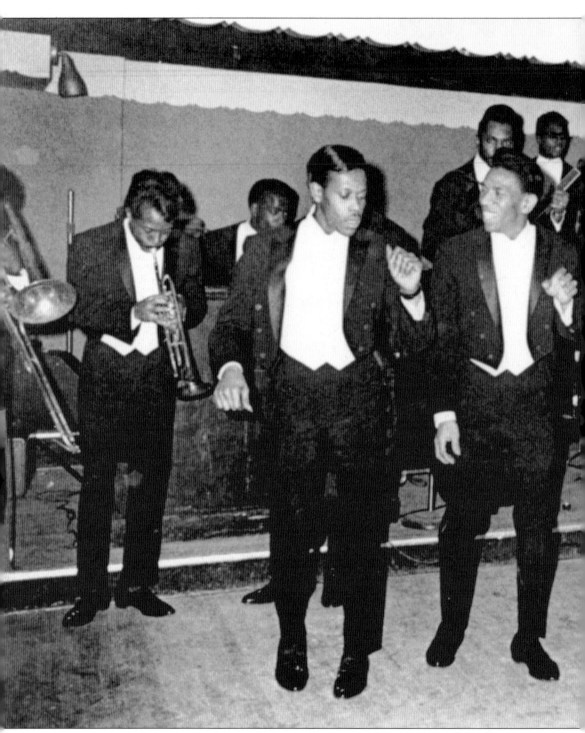

James Brown and the Famous Flames kick out the jams in this 1960s publicity photograph. The group began in the mid-1950s, when Brown formed a vocal group and recorded a demo in Macon, Georgia. The group came to Cincinnati many times to perform in local clubs and make new records at King. Brown was a taskmaster who fined members for small infractions.

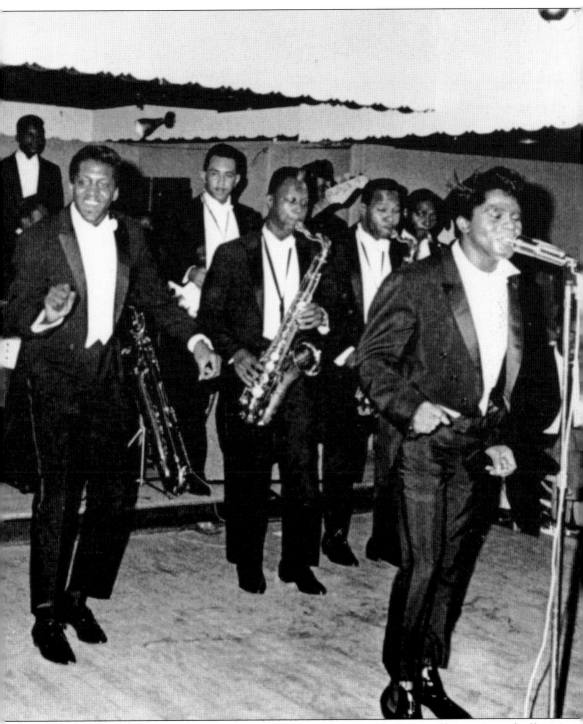

Of course, his band was known for giving a good show. Once the Famous Flames squared off in a battle of the bands with the C. C. Riders, who backed up Wayne Cochran, another King Records artist of the 1960s. Later, Brown's funky backup group, the JB's, included at times Bootsy Collins, Maceo Parker, and Fred Wesley. (Author's collection.)

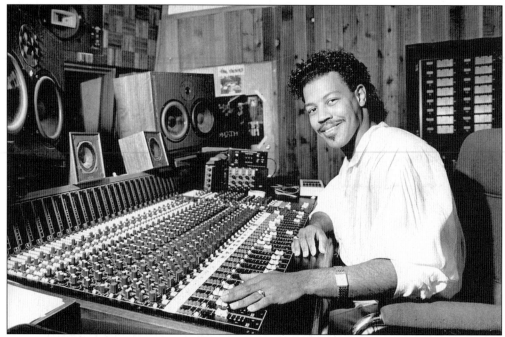

Reggie Calloway operates the control board at the old Queen City Album (QCA) Company studio on Spring Grove Avenue in the early 1980s. Calloway, another Cincinnati rhythm and blues product, used the studio to produce records. He was a member of the hit band Midnight Star, which formed in Louisville in 1976. They recorded "Freak-A-Zoid." (Dick Swaim.)

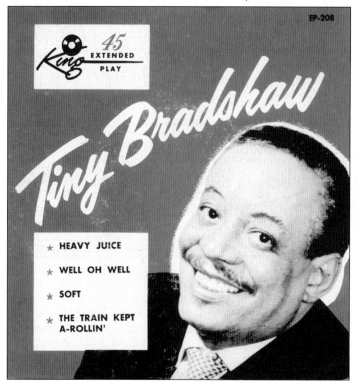

Vocalist and bandleader Myron "Tiny" Bradshaw was born in Youngstown, Ohio, in 1905. He formed his own group in 1934 and finally started recording for King Records in 1950. "Well, Oh Well" and "Soft" were among his five big hits. When they ended in 1953, he was already 48 years old. He died in 1958 and was buried in Cincinnati. (Author's collection.)

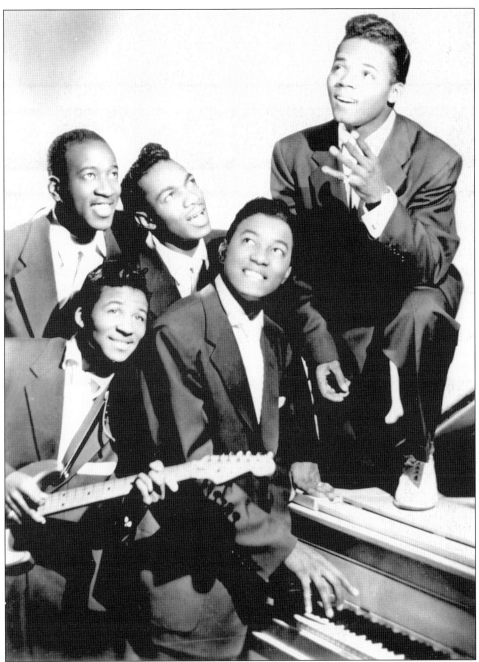

Henry Booth, Lawson Smith, Sonny Woods, and Lawson Smith founded the Royals in Detroit in 1952. The following year they signed with King Records's federal subsidiary, with Henry "Hank" Ballard replacing Smith as lead vocalist. They became the Midnighters in 1954. Their early hits included "Work With Me Annie," "Sexy Ways," and "Annie Had a Baby." Ballard wrote "The Twist" and the group recorded it at King's studio in Evanston. It was a R&B hit, but not nearly as successful as Chubby Checker's version. Hank Ballard and the Midnighters continued to record hits: "Finger Poppin' Time," "Let's Go, Let's Go, Let's Go," and "The Hoochi Coochi Coo." In this picture, Ballard is shown standing on the piano. (Author's collection.)

Herman Griffin was a Cincinnati resident, independent producer, and vocalist who had two fascinating stories. He was Motown founder Berry Gordy Jr.'s first recording artist. Griffin also toured with the Beatles in England during their heyday in the mid-1960s. He was then married to another Motown graduate, Mary Wells, the tour's costar. (Author's collection.)

Albert Washington was Cincinnati's premier blues singer of the 1960s and 1970s. He recorded for a number of companies, including Fraternity. This record is interesting for several reasons. It was written and produced by company owner Harry Carlson, a big-band lover who wrote mostly pop songs. It was recorded at Jewel Recording in Mount Healthy. And it featured rocker Lonnie Mack on guitar. (Author's collection.)

Earl Bostic was born in Oklahoma and became an artist with the alto sax. He played with Lionel Hampton, Cab Calloway, and other black big bands before going solo and recording for King Records. He was one of the label's top instrumentalists for years. He recorded in the King studio in Evanston. His No. 1 R&B hit was "Flamingo." (Author's collection.)

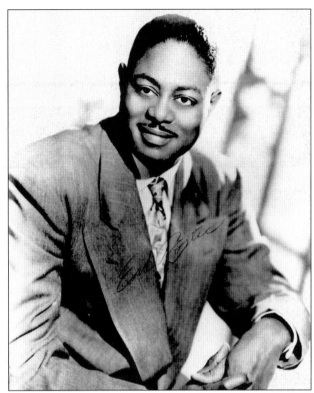

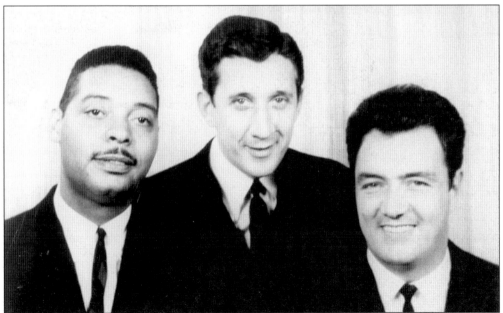

Drummer Dee Felice—born Emidio DeFelice—recorded for King's Bethlehem Records subsidiary. He performed with greats such as Sergio Mendes and James Brown. This photograph shows the jazz man himself flanked by fellow bandmates Lee Tucker (left) and Frank Vincent (right). Felice also performed on local television shows. His daughter now operates the Dee Felice Café in Covington, Kentucky. (Shelly Nelson.)

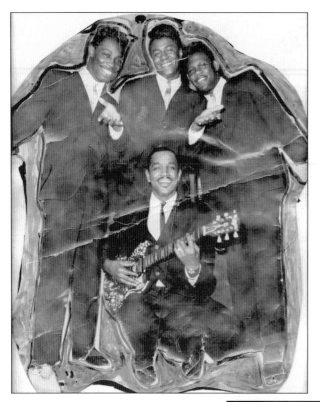

This is Cincinnati vocalist Charles Spurling's first band, the Holidays, as depicted in a 1958 photograph. The musicians are (left to right) James Boles, Charles Farby, and Curtis Josh. Spurling is in front. He grew up in a musical family, and he sang in Cincinnati and on the road for years. (Charles Spurling.)

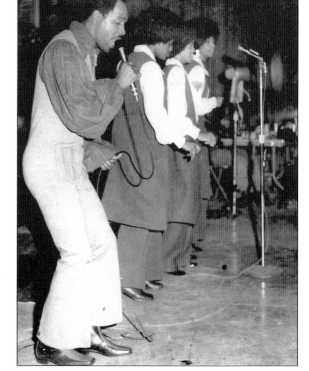

Charles Spurling sings as the Lovejoys back him at a local performance in the mid-1960s. Spurling worked as an A&R man for King Records and recorded for the label as a singer. One of his releases was "Popcorn Charlie." (Charles Spurling.)

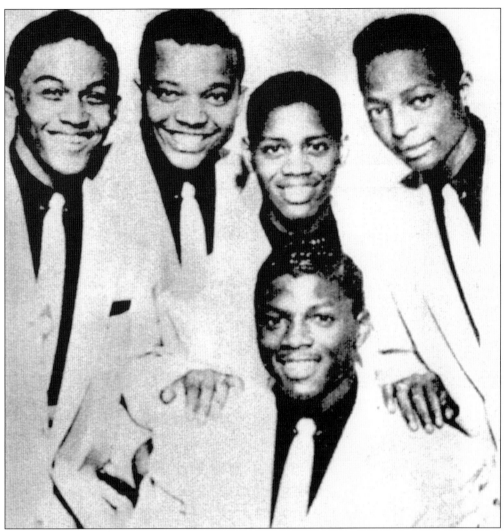

Otis Williams and His Charms came out of Cincinnati at the dawn of the teen doo-wop movement. Williams attended Withrow High School. He chose music over a Cincinnati Reds contract and an Ohio State football scholarship. The Charms went to No. 1 on *Billboard*'s R&B chart in 1954 with the original "Hearts of Stone" on King Records's DeLuxe subsidiary label. A half a dozen hits later, the group had established itself as a strong live act, traveling all across the country. "Disc jockeys would call my mother and book me at record hops," he said. "When I'd come back home from a tour, I'd have to say, 'Now, Mom, I don't need to do these hops for free anymore.' She wanted to be involved." This photograph shows the group as it was in 1956: (left to right) Lonnie Carter, Matthew Williams, Rollie Willis, and Winfred Gerald. Otis Williams is in the middle. (Otis Williams.)

William Edgar "Little Willie" John, a Detroit resident, recorded many hits for King Records in the 1950s and early 1960s. He introduced "Fever" and the fine "Talk To Me, Talk To Me." Unfortunately, the erratic John never lived to enjoy his success. He was convicted of manslaughter in 1966 and died in Washington State Prison in 1968. (Author's collection.)

An accomplished vocalist, arranger, producer, and songwriter, Kenny Smith started with the Enchanters at Withrow High School in 1957. He went on to star in his own locally produced and syndicated musical television show *Soul Street*, and recorded for several national record companies, including Fraternity, RCA, Chess, and Columbia. He wrote "Think Before You Walk Away" by the Platters. (Author's collection.)

Eight
AT THE HOP

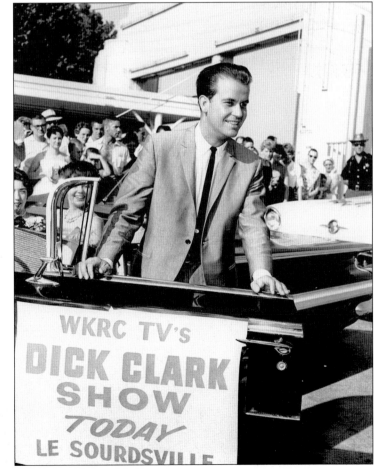

American Bandstand host Dick Clark arrives at LeSourdsville Lake Amusement Park in Butler County for a rock show that he cosponsored with WKRC-TV in Cincinnati. This photograph was from the early 1960s, when Clark traveled around the country promoting such shows with local and national acts. LeSourdsville presented them on a stage that hung over the midway. Other acts performed in the park's Stardust Gardens. (Dale Wright.)

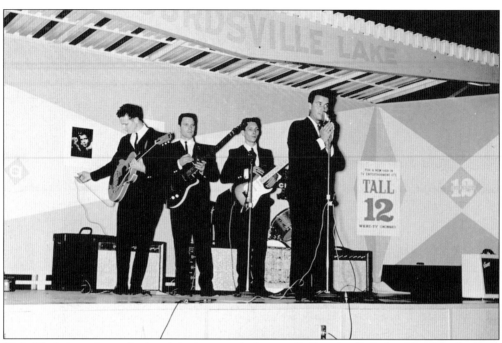
Dick Clark introduces the band during a rock show at LeSourdsville Lake. The Wright Guys often backed up nationally known singers at the park's shows. (Dale Wright.)

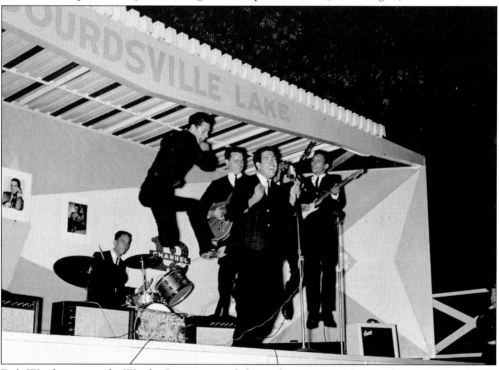
Dale Wright sings as the Wright Guys jump and play at the same time during a hop at LeSourdsville Lake in the early 1960s. It was a different world then, before the long-haired bands arrived and concert admission prices started to increase sharply. (Dale Wright.)

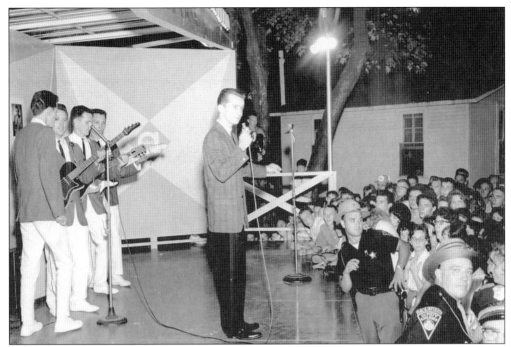

Cincinnati's own Carl Dobkins Jr. entertains the crowd at LeSourdsville Lake Amusement Park in Butler County during a Dick Clark rock-and-roll caravan in the early 1960s. Dobkins's hit record was "My Heart Is An Open Book." Backing him is the Wright Guys. (Dale Wright.)

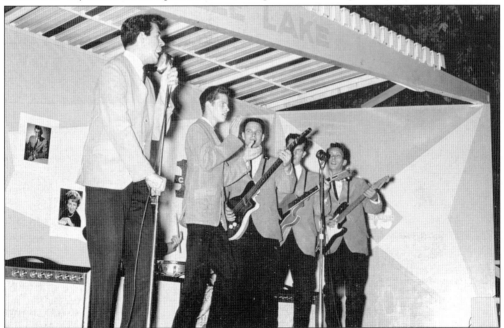

The Wright Guys back up Dale Wright during a WKRC-TV concert in the mid-1960s. Members included Dave Taylor and Benny Terrell, drums; Johnny Reagan, guitar; Ray Hart, lead guitar; Ron Harding and Dan Hon, rhythm guitar; Don De Bord, bass; and Ron Mack, backing vocals. (Dale Wright.)

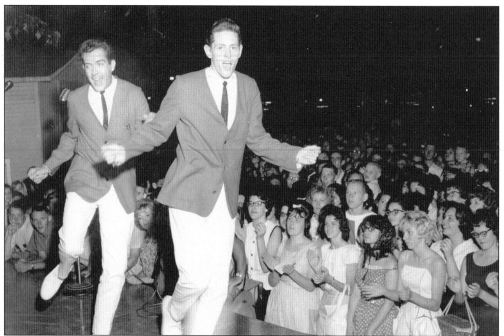

The Wright Guys kick up their heels during a concert at LeSourdsville Lake. Dale Wright (left) and a band member dance and show off their white slacks and shoes. In those days, bands often presented dance routines as well as music. A few of the girls in the crowd look bored by it all. They are dreaming of the coming of Moby Grape. (Dale Wright.)

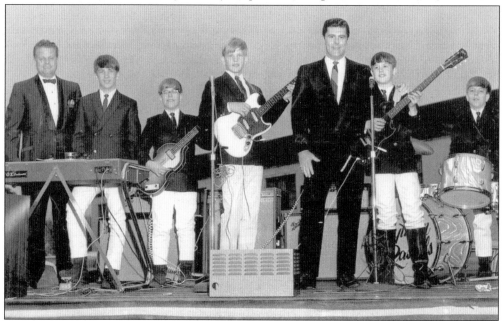

WLW-T personality Bob Braun introduces the Cavaliers at a promotional hop held at a Lincoln-Mercury dealership on Titus Avenue in Middletown in this c. 1966 photograph. Members are, from left to right, Dennis Beatty, Mike Morea, Keith Combs, unidentified, and unidentified. The man to the left is a car dealer. (Steve O'Neil.)

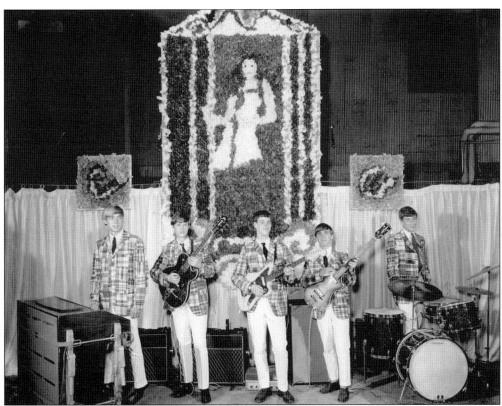

The Intruders mesmerize their teen audience with guitars and plaid jackets at a teen hop around 1965. The band consisted of—in no particular order and at various times—Kent Goforth, Pete Weitzenkrone, Paul Goodwin, Dave Johnson, Terry Harrison, and John Reagan. The high school boys from Middletown performed at fraternity dances and parties in Cincinnati, Oxford, and Middletown. They even brought with them their own business cards. (Kent Goforth.)

The Intruders

J. REGENSBURG	*L. Guitar*	D. JOHNSON	*Drums*
P. WEITZENKORN	*R. Guitar*	P. GOODWIN	*Piano*
K. GOFORTH	*B. Guitar*	T. HARRISON	*Vocal*

Phone For Engagements

JIM BROWN *Mgr.* 422-6783

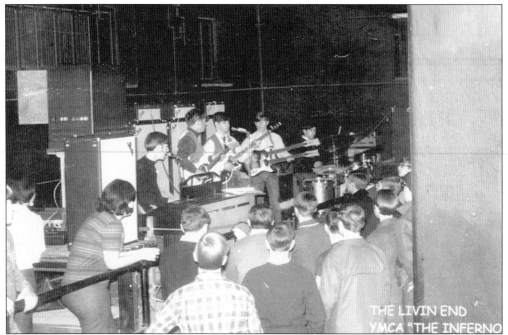

The Livin' End entertains at the Inferno, the teen club at Middletown's YMCA, in this c. 1967 photograph. Members are, from left to right, Brad Sutton, organ; Gregg Clark, lead guitar; Steve O'Neil, bass and vocals; Tom Sweeney, rhythm guitar; and Pat McConaughy, drums. The boys organized a girl group, the Ruby Begonias, to back them up. The band enjoyed the style of the Electric Flag and Blood, Sweat, and Tears. (Steve O'Neil.)

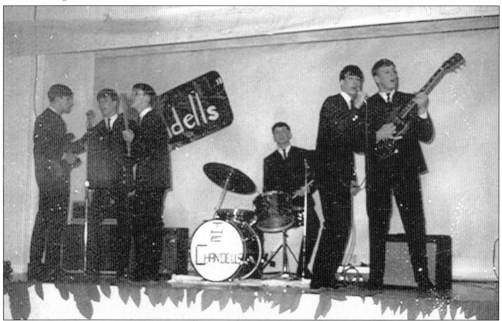

The Chandells rock at a teen dance around 1966. Leader Rob Hegel wrote pop-rock songs for the group, but they were not released. The band stayed together for two years. The Chandells were named the No. 1 band in southern Ohio in a contest of 800 bands. (Rob Hegel.)

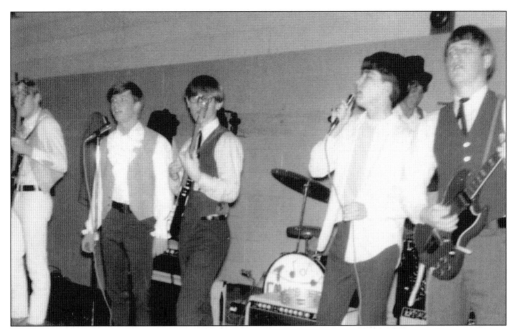

The Chandells formed in Centerville and frequently headed south to Greater Cincinnati to play gigs. Later, members attended the University of Cincinnati and continued to play music there. They were Geoff Hearsum, bass; Craig Carlson, rhythm guitar; Mike Reed, drums; Tim Daum, lead guitar; Dale Graham, vocals; and Rob Hegel, vocals, leader, organ, and songwriter. (Rob Hegel.)

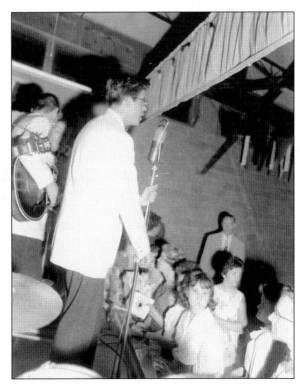

Dale Wright, seen here around 1957, performs at a record hop somewhere in Cincinnati. He was in demand because of his nationally charted record, "She's Neat," which he recorded with the band the Rock-Its. Here he sings to the young crowd. (Dale Wright.)

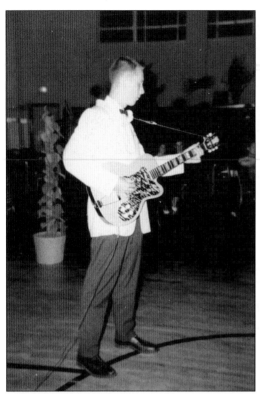

The Rock-Its guitar player blasts some licks as the crowd dances. Group members included Gene Schuder, lead guitar; Randy Stayle, guitar; Pete Reed, drums; Merle Williams, vocals and guitar; and John Wisegarber, whistle and ukulele. (Dale Wright.)

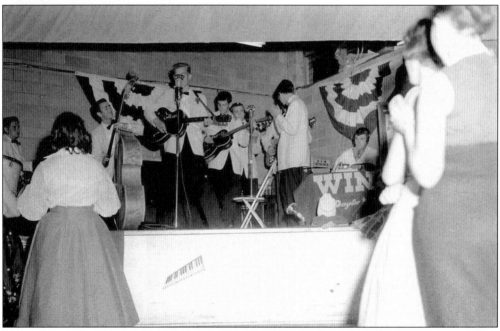

Notice how styles change in only 10 years. The Rock-Its are dressed in white sport coats. Their hair is short, and their names appear on their instruments. The performer strumming the guitar is named Merle. WING, a Dayton rock radio station that is broadcasting the dance, frequently came into Cincinnati to promote concerts. (Dale Wright.)

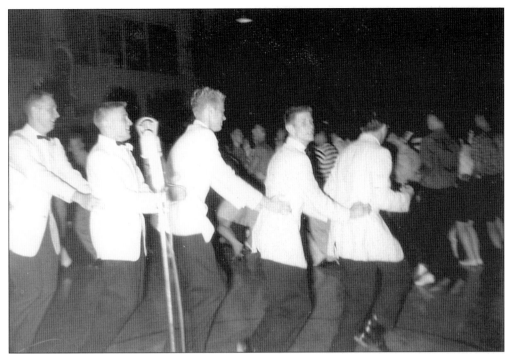

Is that a conga line? It looks like one. Despite the hour, the Rock-Its continue to rock as the night winds down. They represent every band that ever played at every high school hop. (Dale Wright.)

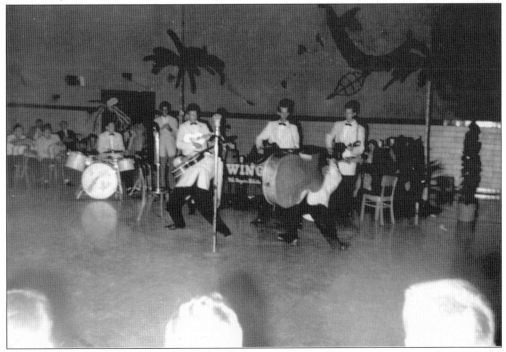

The Rock-Its and Dale Wright keep the students entertained throughout the night. Note the fake palm trees. (Dale Wright.)

Identified only as Pete, the Rock-Its drummer keeps a steady beat throughout the night. It is unusual to find a series of photographs from such small-time hops. They give an idea of what life was like in school in the mid-1950s. (Dale Wright.)

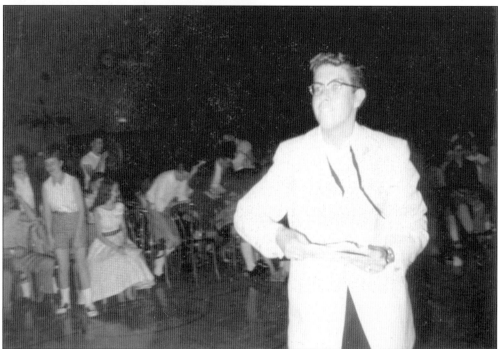

Dale Wright ends the concert by throwing copies of his latest record into the crowd like Frisbees. He had found a novel way to promote his music. (Dale Wright.)

Nine
THEY ROCKED

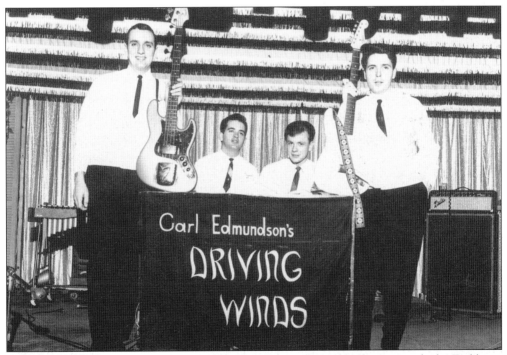

After graduating from high school in 1959, Carl Edmondson played guitar with the Emblems. When they were hired to perform at Ben Kraft's Guys 'n' Dolls nightclub, Kraft changed the group's name to the Driving Winds. The Driving Winds played there for five years. (In this photograph, the sign covering the organ misspells Edmondson's name.) Group members are, from left to right, Panny Sarakatsannis, bass; Tom Dooley, keyboards; Denny Bayless, drums; and Edmondson, guitar. Today Edmondson and the Driving Winds still perform. (Carl Edmondson.)

The Dolphins—Carl Edmondson (bottom), Paul Singleton (middle), and Marv Lockard (top)—pose in this 1964 photograph. That year, Edmondson, who was by then a successful record producer, booked time at the King Records studio and recorded his original song "Hey-Da-Da-Dow" with engineer Dave Harrison. He recruited Singleton and Lockard from the Seniors. The song's pleasing melody and moderate tempo caught the ear of Harry Carlson, founder of Fraternity Records. He released the record, and it received strong airplay across the tristate area. The record peaked on the *Billboard* pop chart at No. 69 on December 19, 1964, at a time when the British Invasion was in full swing. "Unfortunately, 'Hey-Da-Da-Dow' was a turntable hit," Edmondson said. "That is, it received airplay but not large sales. But the song has been remade by other artists over the years." (Carl Edmondson.)

Dusty Rhodes, a top disc jockey at Cincinnati's WSAI, introduces Dale Wright and the Wright Guys at LeSourdsville Lake Amusement Park's Stardust Gardens in this c. 1965 photograph. Rhodes, who is still on the radio in Cincinnati, appeared there often with local and national rock bands. The park booked many rock bands of the period, including the McCoys, the Left Banke, and other touring groups. (Dale Wright.)

Dusty Rhodes was so popular that from 1964 to 1967 he even had a Cincinnati rock band named in his honor. The Rhode Runners were Fred Boone (left), Don Mangus (center), and Frank Gilb (right). Mangus and Gilb reunited in 2006 and wrote two new songs for the *Rhode Runners Revisited* compilation. "Dusty Rhodes wrote a nice liner note in the new album," Mangus said. "What a trip!" (Don Mangus.)

The original boy band was Gary and the Hornets from Franklin. They often performed in Cincinnati, and WSAI played their local rock hits "Hi, Hi Hazel" and "Kind Of A Hush." Gary Calvert, the leader, singer, and guitarist, was 12. He performed with his brothers, bassist Greg, 14, and Steve, the seven-year-old drummer. In this picture sleeve photograph, they all look seven. (Author's collection.)

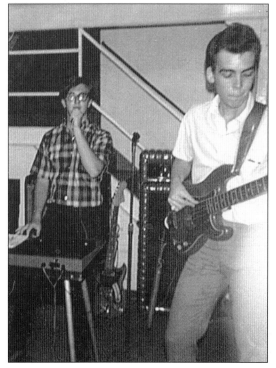

Inspired by songs about cars, the Geargrinders formed in 1964. Personnel included Tim Peel, lead guitar, and Johnny Dick, drums. In this 1966 picture, the band plays on the Johnson Party Boat on the Ohio River in Cincinnati. Michael Banks is on the right, playing Fender bass, and organist Steve Pickers plays the Baldwin organ. Banks is now a best-selling author. (Michael Banks.)

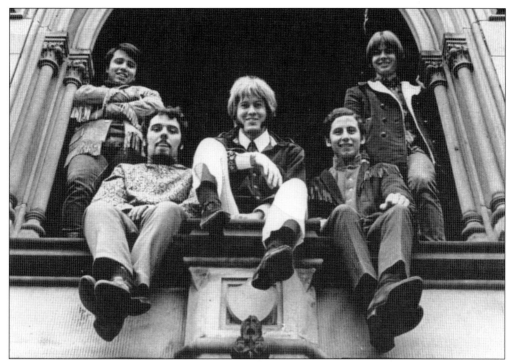

The US Too Group—four guys from Finneytown in Hamilton County—performed in the area from about 1965 to 1969. In late 1966 or early 1967, they entered the King studio to record four of drummer-vocalist Len Gartner's original songs, including the lively pop tune "The Only Thing To Do." They released it on their own label, Jinx Records, named for a member's dog. Later Counterpart Records discovered the song, and turned it into a regional hit. "The song was about a relationship that busted," Gartner said, "and she [former girlfriend] had to hear about it for months while it was played on the radio."

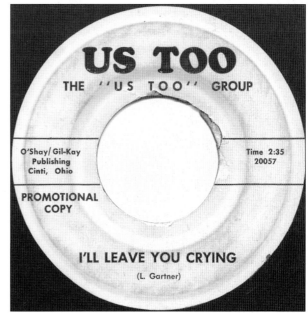

Members over the years also included Joe Madrigal, Tom Whizner, Glen Davis, and Bobby Dickens. The band also cut Gartner's "I'll Leave You Crying," which came in two versions—one on their own label and the other on Hi Records of Memphis. (Leonard Gartner.)

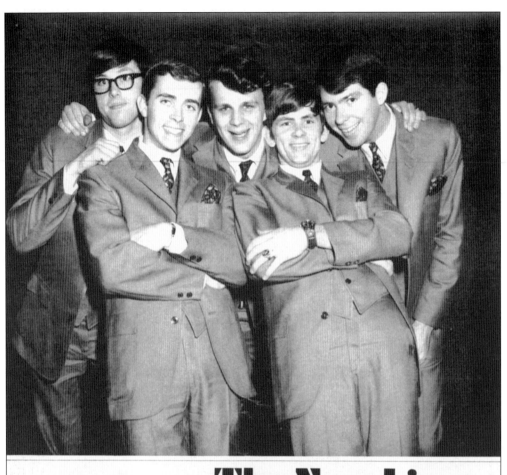

The New Lime of Cincinnati also recorded regional hits for Shad O'Shea's Counterpart Records of Cheviot. This advertisement for "That Girl" comes from their original hit, which he placed with the larger Columbia Records. (Author's collection.)

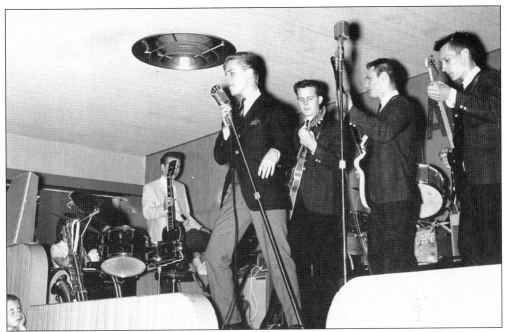

Brian Hyland, the singer of "Sealed With A Kiss," performs at LeSourdsville Lake Amusement Park in Butler County about the time his hit was released by ABC-Paramount Records. He was one of many nationally known singers who appeared at the park in the 1960s. Backing Hyland are members of the Wright Guys. (Dale Wright.)

This Butler County rock band from the mid-1960s played at dances across the Cincinnati area. They had the most novel publicity photograph and name, although some people claim the band used another name at times. But the Rapscallion Circle is still remembered. (Steve O'Neil.)

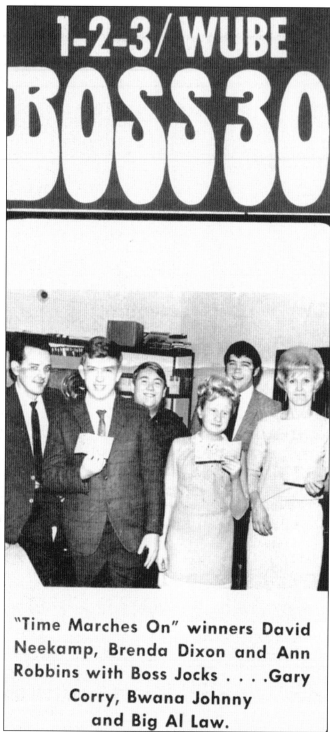

"Time Marches On" winners David Neekamp, Brenda Dixon and Ann Robbins with Boss Jocks Gary Corry, Bwana Johnny and Big Al Law.

In the late 1960s, WUBE was Cincinnati's No. 2 commercial rock radio station. Although its signal was weaker than WSAI's, WUBE was popular and maintained a stable of interesting disc jockeys, who at the time included "Boss Jocks" Bwana Johnny and Big Al Law. (Author's collection.)

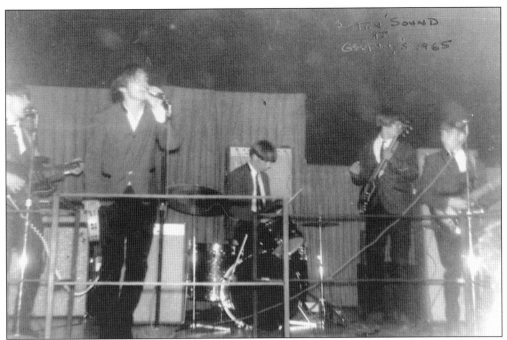

The Datin' Sound performs at Granny's in Butler County in 1965. The Middletown area pop-rock band consisted of (left to right) Terry Pastor, bass; Danny Riley, vocals; Ronnie Clinger, drums; Gary Morris, lead guitar; and Danny Clifford, rhythm guitar. They played for parties and small concerts. (Steve O'Neil.)

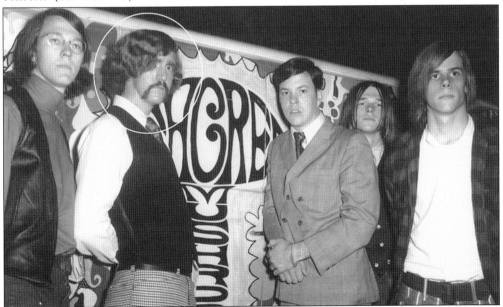

Sacred Mushroom was one of Cincinnati's first psychedelic bands. Members were (left to right) Larry Goshorn, lead guitar; Fred Fogwell, rhythm guitar; Dan Goshorn (Larry's brother), vocals; Doug Hamilton, drums; and Joe Stewart, bass. The popular group stands in front of a wildly painted equipment van. Larry Goshorn went on to join Pure Prairie League, after it was formed in Cincinnati in 1969. (Larry Goshorn.)

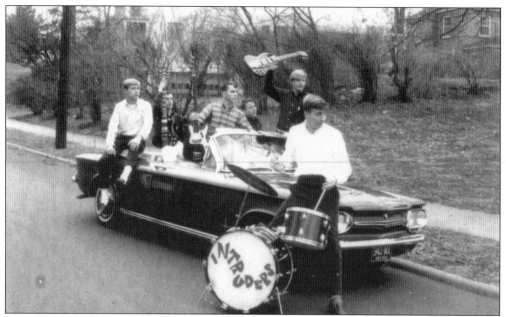

The Intruders of Middletown cannot stop rocking, not even while loading their "staff car," a mid-1960s Chevrolet Corvair. The band played gigs at fraternity houses at Miami University in Oxford. On some Friday nights they would sleep there after a performance and get up the next morning and prepare for another gig on Saturday night. The boys were in high school at the time. (Kent Goforth.)

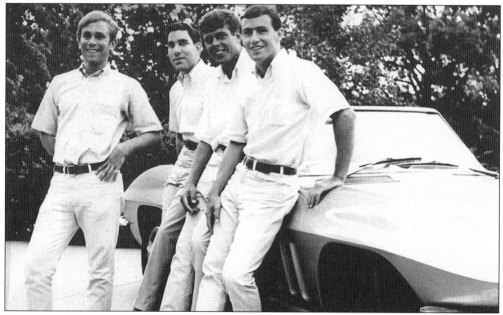

Strangers in Town took band staff cars to a new level with their Corvette. Band members met at the University of Cincinnati—where this photograph was taken—and they played gigs throughout the region. They recorded a regional hit, "Inside Outside," produced by Herman Griffin. The four members, all vocalists, were (left to right) Tom Hyman, James Getz, Bob Risch, and John McEntyre. (Strangers in Town.)

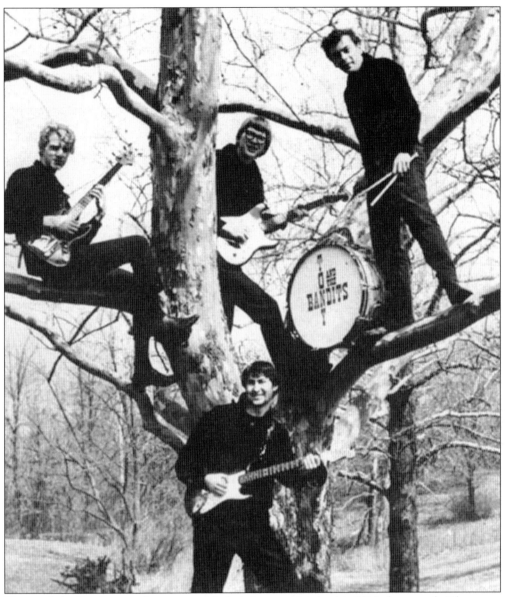

Tony and the Bandits stand in a tree with their instruments in this 1966 photograph. The group had a regional hit, "It's a Bit of Alright" in 1965, and appeared on the *Shindig* rock television show. Tony Brazi and Ron Bodinger came from Cleveland to Cincinnati and started the band, which played often in Oxford. Other band members at times included Bob "Dude" Dudak, Bill Bartlett, Ivan Browne, and Bill Albaugh. (Don Mangus.)

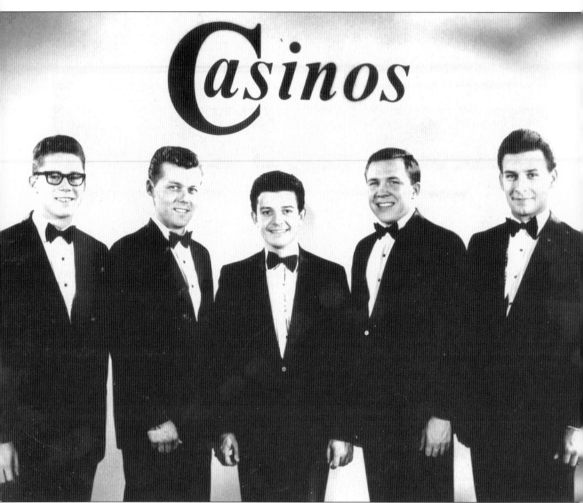

This photograph shows the Casinos personnel when "Then You Can Tell Me Goodbye" hit the top of the national charts. The group soon expanded, but at this time, in March 1967, it was guitarist Mickey Denton, bassist Ray White, lead vocalist Gene Hughes, pianist Bob Armstrong, and drummer Bob Smith. The Casinos discovered many talented acts and allowed them to perform during their shows, including the Heywoods at the Touche Club. "We played the Playboy Club and the Desert Inn," organist Armstrong said. "We had a bona fide show. We were not just a group that recorded and played hops. Locally, we played at the Lookout House and Beverly Hills Supper Club. We hired groups to open for us. We'd set up for six months straight." (Bob Armstrong.)

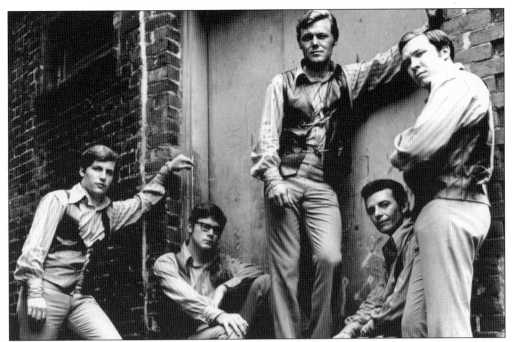

The Casinos are seen here as they appeared in 1971. By then, they had conceded to hipper clothes. The group had reduced its size from the larger band that emerged after the hit record in 1967. They continued to play the best clubs in town. (Author's collection.)

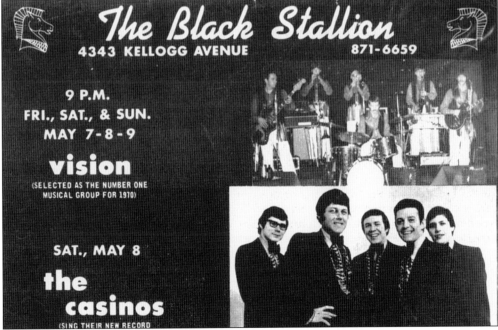

The Black Stallion nightclub on Kellogg Avenue was a good place to dance and listen to music from talented acts such as the Casinos and Vision. In this 1970 advertisement, the Casinos are pledged to sing their new Kris Kristofferson song "Loving Her Was Easier" on Fraternity Records. (Bob Armstrong.)

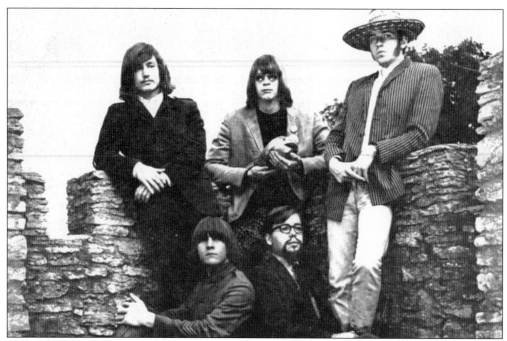

The Lemon Pipers, a Cincinnati rock band, recorded the hit "Green Tambourine" in 1968. The group featured Bob Nave, organ; Ivan Browne, lead vocals; Bill Bartlett, lead guitar; Steve Walmsley, bass; and Bill Albaugh, drums. They first had a local record that was produced by Tom Dooley of the Driving Winds. (Author's collection.)

Bittervetch came from the University of Cincinnati in the mid-1960s and featured former members of the Chandells, including vocalist Rob Hegel. When college ended, Hegel was the only band member who stayed in the music business. He recorded "New York City Girl" for RCA at Counterpart Studios in Cheviot. A fine pop songwriter, he now lives in California. He has written for Air Supply and other acts. (Rob Hegel.)

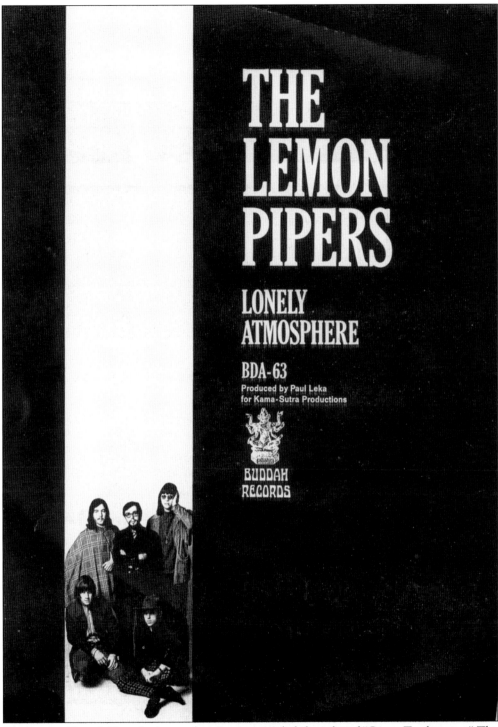

The Lemon Pipers's "Lonely Atmosphere" never equaled the sales of "Green Tambourine." The band recorded their hit at Cleveland Recording, and producer Paul Leka added strings in New York. (Author's collection.)

Canon, one of Cincinnati's more popular party bands, formed after the Casinos broke up in about 1974. It continued until 1988 and featured the talented Vicki Taylor as well as Bob Armstrong (left of Taylor) and Ray White (right of her), as well as guitarist Carl Edmondson (far right), formerly of the Driving Winds. (Bob Armstrong.)

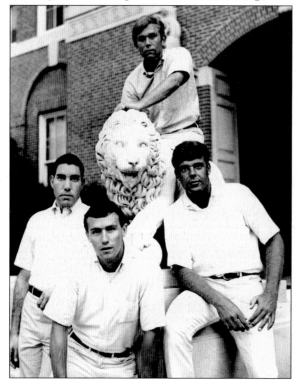

Strangers in Town hired backup musicians. After the group stopped performing, pianist Randy Edelman went to California, recorded some fine pop albums for himself, wrote hits for Barry Manilow and others, married singer Jackie DeShannon, and composed movie scores. (Strangers in Town.)

Bo Donaldson led the Heywoods, a band that performed all over Cincinnati in the late 1960s and early 1970s. After some releases on the local Queen Bee label and a national one, the group went to No. 1 with "Billy Don't Be A Hero" on ABC Records. (Author's collection.)

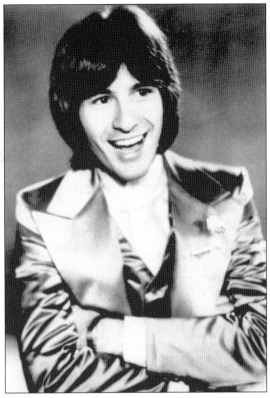

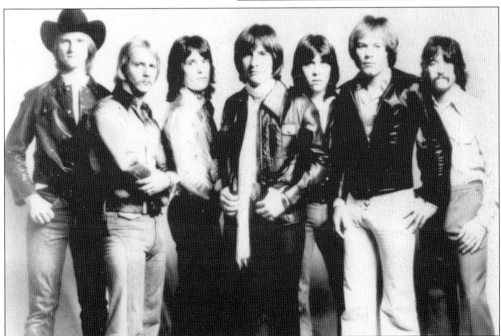

Donaldson also sang "Who Do You Think You Are," the Heywoods' second hit on ABC Records. After two more charted records on ABC, the band sank off the charts in 1975. (Author's collection.)

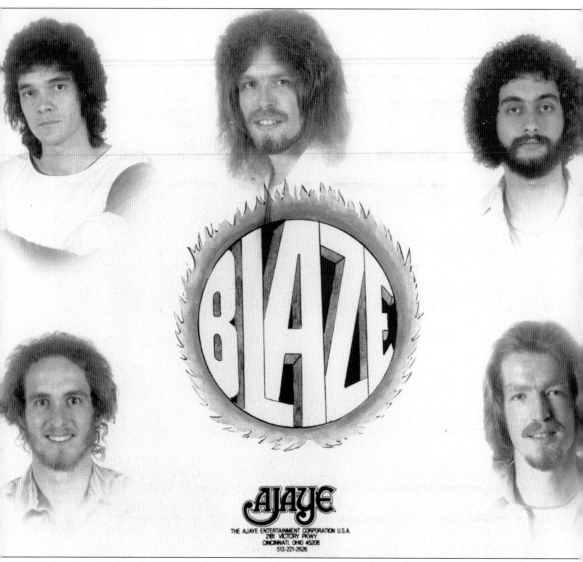

Blaze formed in Cincinnati about 1974 and started playing clubs from Michigan to Florida. At Counterpart Creative Studios in Cheviot the group recorded the old soul standard "Knock On Wood," but their original flip side, "Jamie," caught all the attention when Fraternity Records released it about 1975. Later the band moved on to Columbia's Epic label and a brief national chart appearance. Members were (clockwise, beginning lower left) Paul Meyers, lead guitar and vocals; Charlie Fletcher, organ, synthesizer, clavinet, piano, and vocals; Chris Jolly, drums; Tony Paulus, piano, organ, guitar, and vocals; and Bill Jolly, bass and vocals. (Shad O'Shea.)

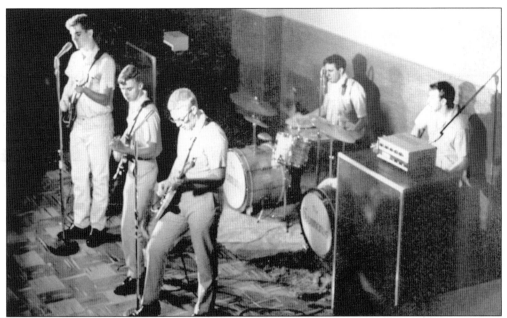

The Commands came out of Aiken High School in 1964. They were Karl Sjodahl, guitarist and vocalist; Larry Swan, guitarist; Tom Bruckmann, guitarist; Jeff Willis, drummer; and Tom Algeier, original drummer. They played at school gigs, community dances, events, and private parties. To avoid confusion with a black vocal group that recorded in Houston, the Commands later changed their name to THE, which caused a problem. "WSAI disc jockeys told our agent that they wouldn't promote our gigs unless we changed the name, because they couldn't say it without sounding stupid," recalled Sjodahl. "So we added periods after the letters and became T.H.E." Later members included Mark Winkle, organ, and Don Schenk, lead guitar. The T.H.E. name was used for the last two years that the band performed in Cincinnati. (Karl Sjodahl.)

Jaye Entertainment booked some of Cincinnati's more popular rock bands. In 1970, they included the Haymarket Riot, Whalefeathers, the Casinos, Borrowed Thyme, and the Bitter Blood Street Theatre. In those days, a Calhoun Street address near the University of Cincinnati meant good old rock and roll. (Bob Armstrong.)

BIBLIOGRAPHY

Gentry, Linnell. *A History and Encyclopedia of Country, Western, and Gospel Music.* Nashville: Clairmont Corporation, 1969.

Kennedy, Rick, and Randy McNutt. *Little Labels—Big Sound: Small Record Companies and the Rise of American Music.* Bloomington: Indiana University Press, 1999.

Lyons, Ruth. *Remember with Me.* New York: Doubleday and Company, 1969.

McNutt, Randy. *Guitar Towns: A Journey to the Crossroads of Rock and Roll.* Bloomington: Indiana University Press, 2002.

———. *Too Hot to Handle: An Illustrated Encyclopedia of American Recording Studios of the 20th Century.* Hamilton, Ohio: HHP Books, 2001.

Radel, Cliff. "Dee Felice Tribute Will Hit a Festive Note." *The Cincinnati Enquirer,* October 9, 1991.

Whitburn, Joel. *Top Pop, 1955-1982.* Menomonee Falls, Wisconsin: Record Research, 1983.

———. *Top Country Singles, 1944-1988.* Menomonee falls, Wisconsin: Record Research, 1988.

———. *Top R&B Singles, 1942-1988.* Menomonee Falls, Wisconsin: Record Research, 1988.

Wolfe, Charles K. *Classic Country: Legends of Country Music.* New York: Routledge, 2001.

Across America, People are Discovering Something Wonderful. Their Heritage.

Arcadia Publishing is the leading local history publisher in the United States. With more than 3,000 titles in print and hundreds of new titles released every year, Arcadia has extensive specialized experience chronicling the history of communities and celebrating America's hidden stories, bringing to life the people, places, and events from the past. To discover the history of other communities across the nation, please visit:

www.arcadiapublishing.com

Customized search tools allow you to find regional history books about the town where you grew up, the cities where your friends and family live, the town where your parents met, or even that retirement spot you've been dreaming about.